IMAGES
of America
MILFORD

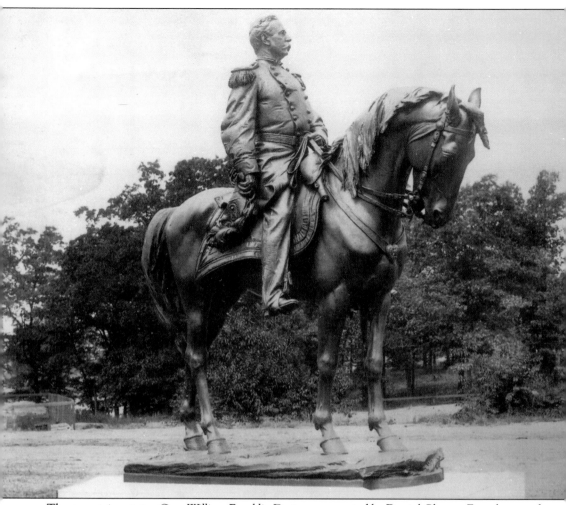

The equestrian statue *Gen. William Franklin Draper* was created by Daniel Chester French, one of America's foremost sculptors. General Draper was one of the first men to enlist in the Civil War from Milford, and he quickly rose through the ranks to become an officer. The statue was a gift from his wife, Susan Preston Draper, who presented it to the town on September 25, 1912. It is located in Draper Memorial Park on Main Street. (Courtesy of the Milford Historical Commission.)

ON THE COVER: Central Grocery, the *Milford Gazette*, F.A. Bishop, and M.J. Reynolds were businesses located in this building around 1880. This image shows the corner of Main and Central Streets, which was the heart of downtown Milford. Neighboring townspeople came here to do their shopping and banking. Note the hitching post and the fire hydrant, which was probably one of the first hydrants in town. (Courtesy of the Milford Historical Commission.)

IMAGES
of America

MILFORD

Deborah Eastman, Anne Lamontagne,
and Marilyn Lovell
Foreword by Leila Dunbar

ARCADIA
PUBLISHING

Published by Arcadia Publishing
Charleston, South Carolina

Printed in the United States of America

Library of Congress Control Number: 2014930476

For all general information, please contact Arcadia Publishing:
Telephone 843-853-2070
Fax 843-853-0044
E-mail sales@arcadiapublishing.com
For customer service and orders:
Toll-Free 1-888-313-2665

Visit us on the Internet at www.arcadiapublishing.com

Dedicated to all veterans past and present

CONTENTS

Foreword 6

Acknowledgments 7

Introduction 8

1. Main Street 9

2. Businesses, Quarries, and Shoe Shops 21

3. Houses of Worship and Cemeteries 37

4. Municipal Services and Transportation 45

5. Parks, Military, and Organizations 57

6. Schools and Sports 71

7. Historical Homes and the Hospital 85

8. Music, Entertainment, and Parades 97

9. Misfortunes 107

10. Notable Milfordians 113

FOREWORD

The first time I realized Milford was special, I was just 10 years old. Riding my go-kart through our automotive junkyard and up to the quarry where we swam on weekends and hot evenings, I noticed some cut stone with glints of pink.

When I mentioned it at dinner, my parents told me the story of Milford pink granite. At its height in the late 1800s, there were six quarry companies employing more than 1,000 workers, shipping blocks via train throughout the country. Little would I expect to encounter a bit of Milford in my future travels—from Penn Station in New York City to the First Division Army Monument in Washington, DC, my current residence.

While much has changed since my childhood of the 1960s and 1970s (no more Alpens or Rings Clothing, Crystal Spa, Soda Shoppe, W.T. Grant, Crystal Room, Sweet's, or Davoren's), the essence of Milford carries on in the melting pot of Irish, Italian, Armenian, Jewish, and Portuguese families who have lived here for generations, such as the Delucas, Consolettis, Stoicos, Alves, Murrays, Davorens, McGraths, Manns, Hills, Krikorians, Manoogians, Ruas, Sebastios, and many, many others, some of whom gave their lives in the Civil War, World Wars I and II, Korea, and Vietnam.

The town's great tradition of sports is evidenced through myriad high school champions and professional athletes, including former NFLer Jim Pyne, Hall of Famer Howie Long, and current Major League Soccer midfielder Michael Videira. Milford is also a music community with roots in the Jazz Age, from hometown saxophonist Boots Mussulli and frequent visitors Stan Kenton and Buddy Rich to current musicians Jerry Seeco and the Chaplin Brothers Jazz Band.

And yes, we Milford natives have brains, including Annie Godfrey, who became the first Wellesley College librarian (my mom's alma mater) in 1875 and married Melvil Dewey, who created the Dewey decimal system, which was adopted by libraries in 1876. Another native, Dr. Joseph Murray, performed the first successful human kidney transplant in 1954 and shared the 1990 Nobel Prize in Physiology or Medicine.

Every time I come home to visit my family, I drive by the town hall and the Irish Round Tower, see friends, and wonder, what will be the town's legacy in the next century? In paging through these photographs, I hope you will enjoy the journey through the town's past triumphs and tragedies and take the same pride I do in having been brought up in a town with such a rich history.

—Leila Dunbar

ACKNOWLEDGMENTS

This book is a collaboration of many generous individuals. Unless otherwise noted, images are courtesy of the Milford Historical Commission's collection. All others are courtesy of the Milford Town Library (MTL) or private sources.

The authors extend our profound gratitude to Roger Lamontagne for his technical expertise in scanning and refining hundreds of photographs. His work was flawless. Thank you, Roger! You made this project possible.

Thank-yous go to our proofreaders Robert Andreola, Jeffrie Lovell, and Robert Samiagio. If any errors remain, they are ours, not theirs.

A special thanks goes to librarian Anne Berard for reading many revised drafts; she had faith in our project from its beginning.

To historian Carlo A. Mariano, we have deep gratitude for his impeccable erudition and encouragement.

We are grateful to Robin Philbin for his extensive knowledge of local history, the photographs he loaned to us, and his careful review of the work.

A thank-you goes to railway expert Pat Fahey for sharing his photographs and research.

Thanks go to Paul E. Curran, lifelong scholar of Milford history, honorary commission member, and library trustee emeritus, for sharing his wonderful photographs and stories.

Thank you, to the Milford Historical Commission for access to its archives and meeting space at the museum.

We are grateful to director Susan Edmonds and the trustees of the Milford Town Library for sharing the archives of the Curran Collection.

Thanks go to our patient and supportive acquisitions editor, Caitrin Cunningham.

We thank Leila Dunbar for her personal and enthusiastic foreword.

And, finally, a sincere thanks is due to the great people of Milford.

INTRODUCTION

This book gives a picturesque tour of Milford's history. One can read more complex and complete narratives of the town's origins in Ballou's famous two-volume set and the commission's bicentennial work. But offered here is a stroll through a hundred years of Milford's people and places in charming vintage photographs, some never before shared.

What gave Milford its prominence, the granite quarries and the shoe industry, is only part of the story. The lively business district enjoyed by both locals and commercial travelers was teeming with hotels, taverns, liveries, billiard halls, and restaurants. Factories producing cigars, straw goods, and boxes afforded immigrants good jobs. Buffalo Bill Cody and his troupe performed at the music hall. Rudolph Valentino appeared at the Opera House. The first three-ring circus transported on a flatbed made its debut in Milford. Neighbors and youngsters mingled at penny candy stores and soda shops.

A competitive edge coupled with athletic prowess fueled Milford's excellence in sports. Frank Fahey made it to the major leagues in baseball. Golf, swimming, and harness racing were popular. Three generations of the Pyne family played professional football. Adam Diorio, coach of the Boys' Club wrestling team, was an outstanding boxer.

In a community nicknamed "Music Town," many talents became local celebrities, like the McEnnelly dance band; Lou "Breeze" Calabrese; and Alexander DiGiannantonio, who composed the song "Allegiance" for the town's 150th birthday. Others with real genius for jazz and improvisation, Henry "Boots" Mussulli and Victor "Ziggy" Minichiello, achieved fame performing with international luminaries like Stan Kenton and Charlie Parker. George Morte and Leo Curran booked Duke Ellington and Lionel Hampton as headliners at the nightclub the Crystal Room—a thrill for the locals.

People new to Milford may have slight idea how this town began and became a center of so many important and diverse disciplines: architecture, music, sports, medicine, scientific innovations. Other readers who have lived here all their lives may discover unexpected surprises and fond memories.

We invite you to enjoy this nostalgic view of Milford's past.

—Deborah Eastman

One

MAIN STREET

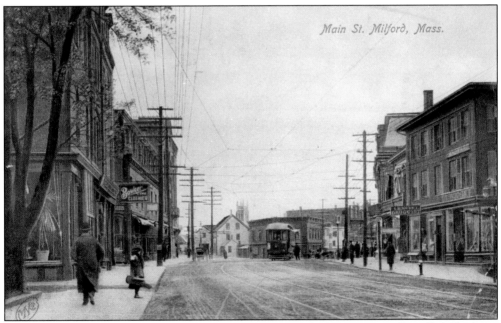

This photograph from around 1900 shows Main Street, which was originally called Sherborn Road. A charming little girl stands on the left with her violin, and a trolley comes up the road. Visible are business blocks and the tower of St. Mary's Church. Milford was always a busy center for locals as well as surrounding townspeople to conduct business.

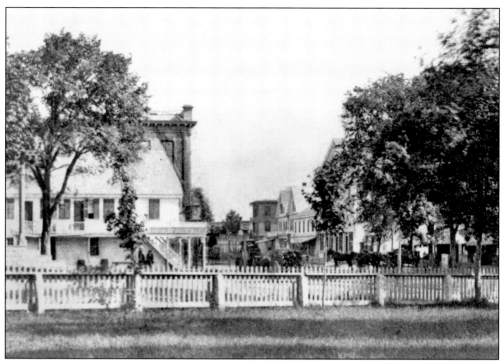

The Claflin Inn, located at the corner of Main and Park Streets, was established about 1805 by John Claflin Jr. It burned down in 1838 and was later replaced by the Mansion House. (Courtesy of Robin Philbin.)

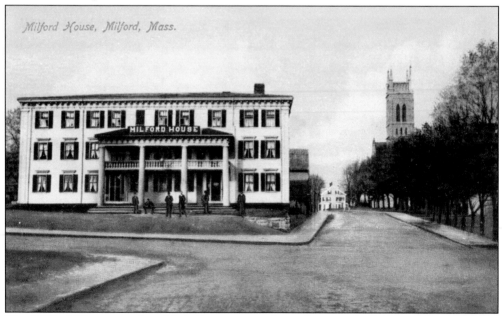

The Milford House stood on Main Street across from the town hall. Originally called the Quinshipaug House, it operated from 1853 until it was sold in 1927. Several hotels were opened in Milford due to the arrival of the trains. This site was later the location of a gas station and is currently home to Tedeschi's Market.

The Mansion House was built in 1873 on the corner of Main and Park Streets, across from Draper Memorial Park. It was the largest rooming house in Milford, with 75 rooms. In back, there was a fine livery stable. The inn was torn down about 1927 to make way for the State Theater. (Courtesy of the MTL.)

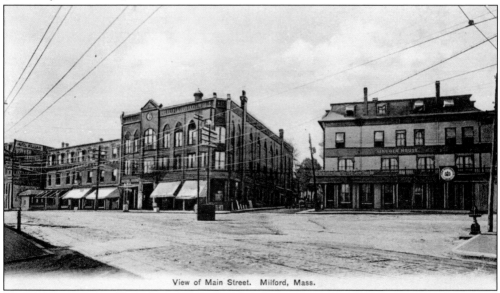

The Music Hall Block, on the corner of Main and Pine Streets, opened in 1880 as a building offering theatrical performances, musical concerts, and the circus. Architect Fred Swasey is credited with designing the building, which was also known as the Opera House. Renowned stars such as Enrico Caruso and Rudolph Valentino performed there. The Lincoln House, on the opposite corner, was a popular boardinghouse. A fire destroyed the building around 1980.

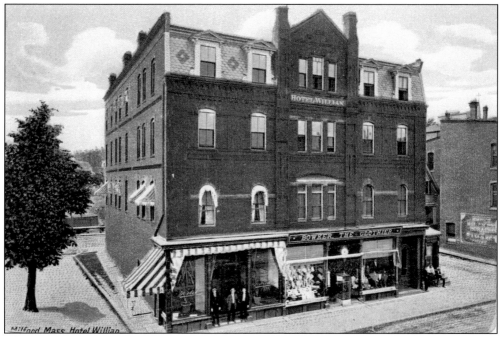

The Hotel Willian opened in July 1887 and offered 40 sleeping rooms. It soon became the accommodation of choice for entertainers and actors appearing at the Opera House. Bowker, the Clothier operated a shop on the first floor. Co-Mac's Café later occupied this location, and it is now a Brazilian café.

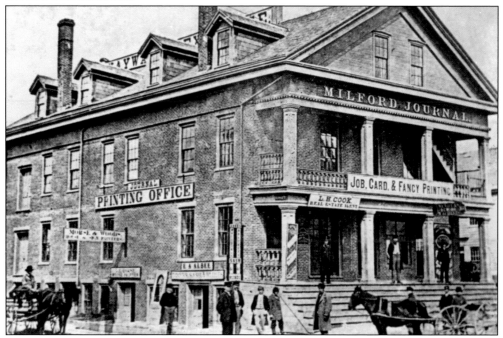

Seen here in 1865 is the old Exchange Building, at the corner of Exchange and Main Streets, which once housed the post office. L.H. Cook is standing in front of his real estate office. The building was also the headquarters for the *Milford Journal*, which ceased publication in 1918.

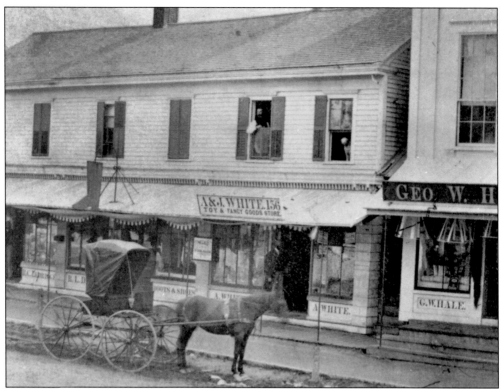

This photograph was taken of the east side of Main Street, between Jefferson and Spring Streets, around 1880. G.W. Hale was a cigar manufacturer in the Tuttle Building, on the corner of Main and Jefferson Streets.

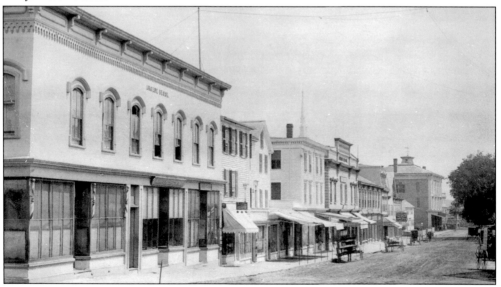

This is the west side of Main Street, with the Arcade Block, built in 1865, in the left foreground. The other buildings had stores on the first floor and large meeting halls on the second floor. They were all constructed about 1859. This site had formerly been occupied by the Union Block, which burned in January 1857.

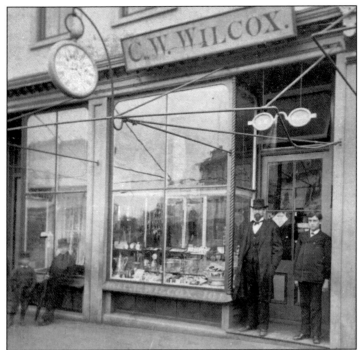

Charles W. Wilcox (left) is shown here standing in front of his business on Main Street with an unidentified person. His business is recorded in the 1869 *Milford Directory*. Wilcox was born in Brookfield, Vermont, and served with distinction in the Civil War as a Vermont volunteer.

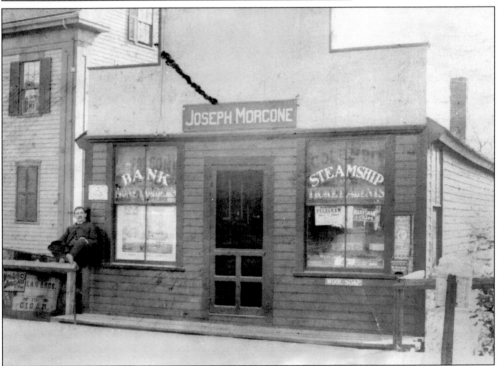

Joseph Morcone sits in front of his first store, which was located on the right side of Main Street just beyond the Upper Charles River Trail. Morcone was the justice of the peace, banker, and ticket and insurance agent for the large Italian population that came to Milford around 1900. Morcone served the town for over 50 years.

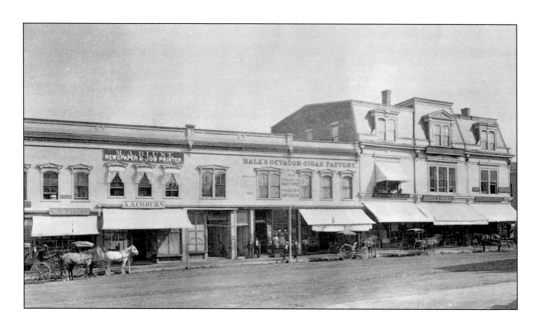

Pictured above is the Blunt Building, on Main Street, which was a busy place in 1880. William B. Hale established a successful cigar business here in 1867. A.A. Coburn's dry goods store is also seen in this early photograph, and the Odd Fellows Building is on the right. Below is the back entrance to the Blunt Building, which is off Jefferson Street. Today, it is the back of a Chinese restaurant, Hunan Gourmet, and it is also occupied by an old-time cobbler.

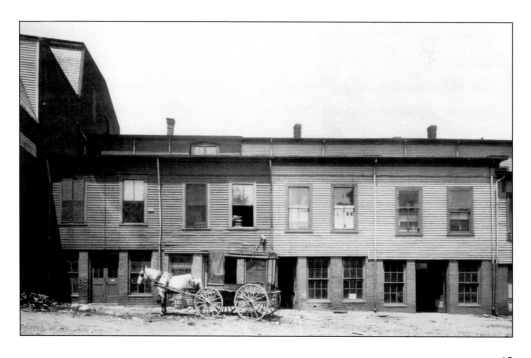

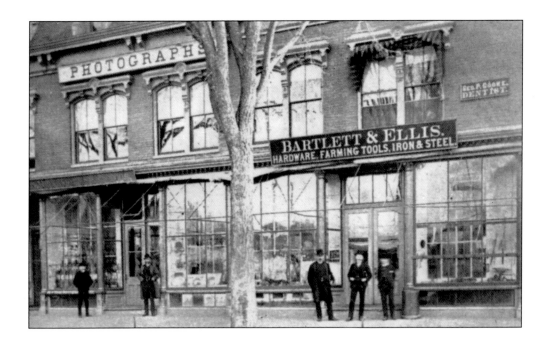

Pictured above around 1880 is the Bartlett & Ellis hardware store, founded in 1868 at 109 Main Street. Standing in the door are, from left to right, Mr. Ellis, Mr. Bartlett, and an unidentified person. Standing next door in front of the New York Boot & Shoe Store are the owner (right) and an employee. Below is the interior of Bartlett & Ellis, showing a well-stocked service business. Parts of this building are now home to the Milford Federal Savings Bank. (Above, courtesy of the Ellis family; below, courtesy of Robin Philbin.)

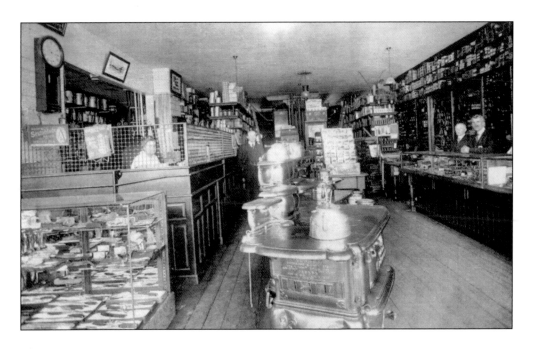

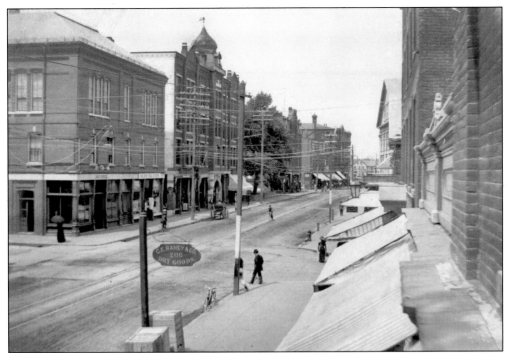

Milford's Main Street is seen here from the corner of Main and Exchange Streets around 1888. The new Hayward Block was built to replace the old Exchange Building, which was destroyed by fire. This is now the Consigli Building, without the third floor. The next large building is the Gillon Block, at 149 Main Street, which was built in 1888 by Patrick Gillon and is listed in the National Register of Historic Places. (Courtesy of the MTL.)

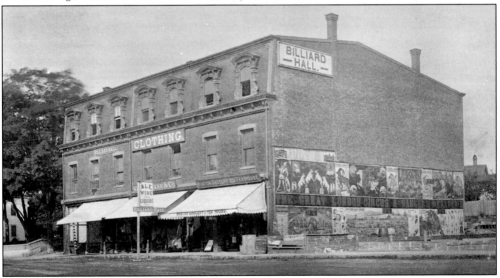

The Billiard Hall, located at 155 Main Street, was built about 1850. The ground floor housed a grocery and clothing store. Posters for the Great London Circus and Sanger's Menagerie are pasted on the brick facade, advertising a July 8, 1871, performance featuring trapeze artists, tightrope walkers, and "wild beasts representing the Four Quarters of the Globe." In 1880, the Milford Music Hall was erected on the lot to the right.

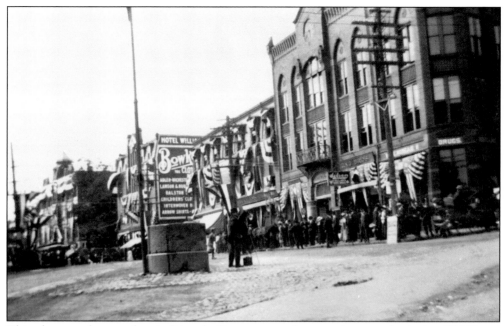

This photograph was taken in Lincoln Square, near the watering trough, during Old Home Week in 1904. The crowd of people is waiting for the parade. The pole is sometimes referred to as the "Liberty Tree," in reference to the famous Liberty Tree in Boston, made famous in 1765 by a group of American patriots.

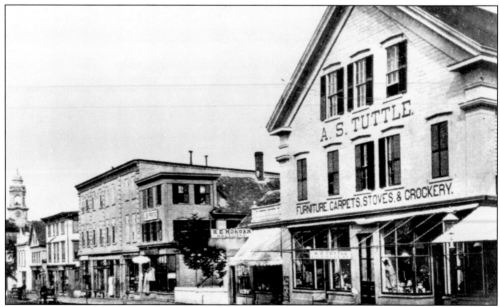

This photograph was taken of Main Street looking toward the town hall around 1880. Businesses shown here include A.S. Tuttle's furniture store, H.E. Morgan's drugstore, and the Hotel Manion. Today, Bill's Pizza, the Turtle Tavern, a barbershop, a Laundromat, and various ethnic stores occupy this area.

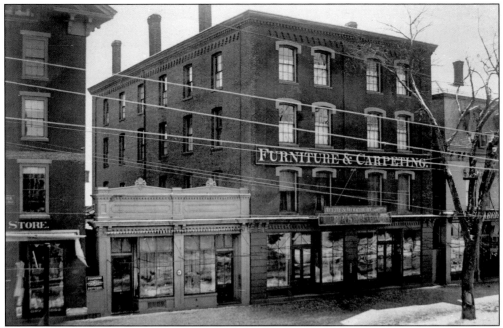

The Avery & Woodbury store was located on the east side of Main Street next to the present Johnny Jacks Restaurant. Orlando Avery and G.P. Woodbury purchased the business from J.W. Harris as a furniture store. The front of this building was blown out in the great hurricane of 1938. (Courtesy of Paul Curran.)

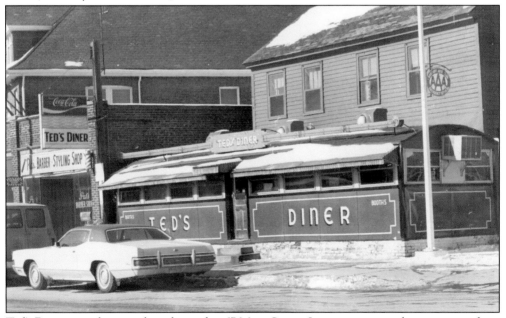

Ted's Diner was a historic diner located at 67 Main Street. It was a very popular spot across from the town hall. Customers entered through a sliding front door and were greeted by John Trotta, the cook. The diner was listed in the National Register of Historic Places but was unfortunately vandalized after being moved to make room for the new Spruce Street fire station. (Courtesy of Pat Fahey.)

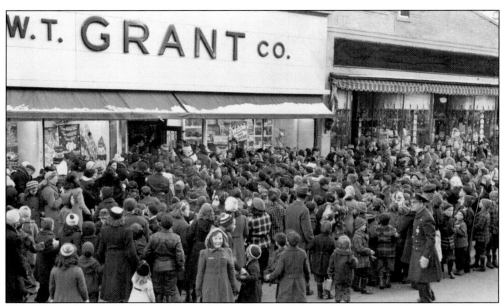

This little girl poses for her picture while a large crowd of people waits to get in to W.T. Grant's "Toy Circus" around 1945. The building is decorated for Christmas. (Courtesy of the MTL.)

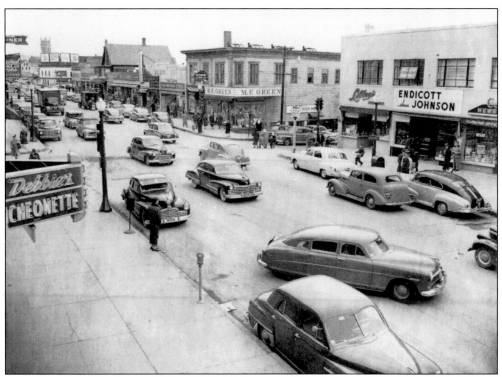

Milford was a bustling center with stores, banks, theaters, restaurants, bars, hair salons, and much more for locals and residents of neighboring towns. It was always an adventure to check out all the stores and greet friends and relatives downtown. Main and Central Streets are seen here in 1953. (Courtesy of Robin Philbin.)

Two

BUSINESSES, QUARRIES, AND SHOE SHOPS

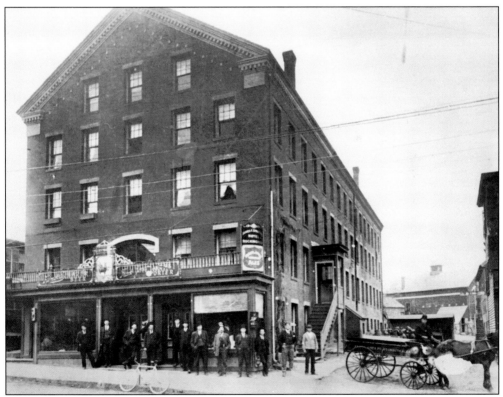

The Jones & Wilkinson Straw Shop was located on Central Street in 1888. It employed 100 workers and sold men's and boys' straw goods across the country. On April 4, 1900, James F. Stratton bought and refurbished the building and operated it as the Rockingham Hotel. The brick building was later occupied by Stone Furniture Company.

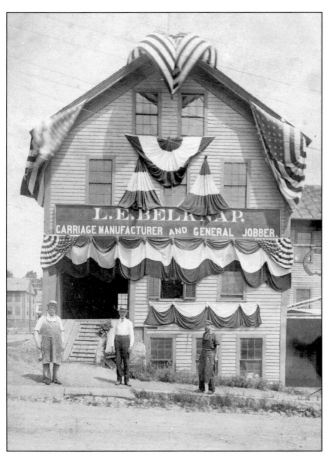

At left, Lemuel E. Belknap (left) stands in front of his business, located in Memorial Square, with two unidentified workers. Belknap started this business as early as 1872. The building is decorated for Old Home Week in 1904. Belknap is seen below in front of his home, at 149 Congress Street, with his business carriage. Note the rather comical sign, "If Uneeda Carriage Repair'd, Go To L.E. Belknap, Memorial Square."

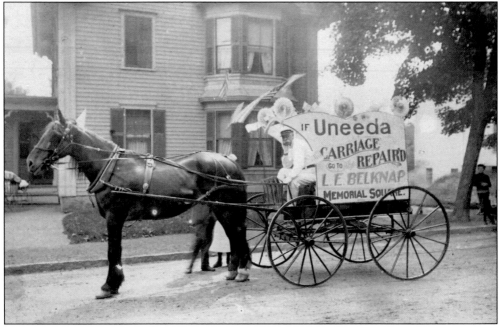

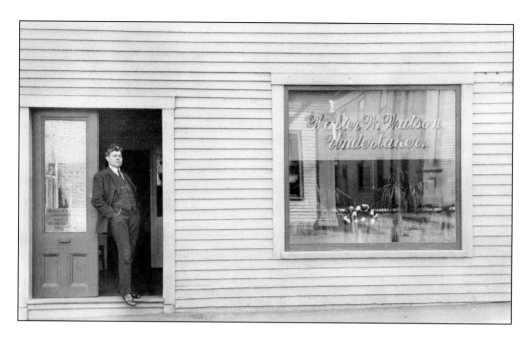

Milford's first funeral parlor (above) was located at 32 Exchange Street and owned by Mr. Wood, a former cabinetmaker, and Mr. Nye around 1838. This business was purchased by Walter W. Watson from Emery & Wood in 1903. Watson is also seen below, in front of his establishment and his 1932 Packard hearse. (Both, courtesy of Dwight Watson.)

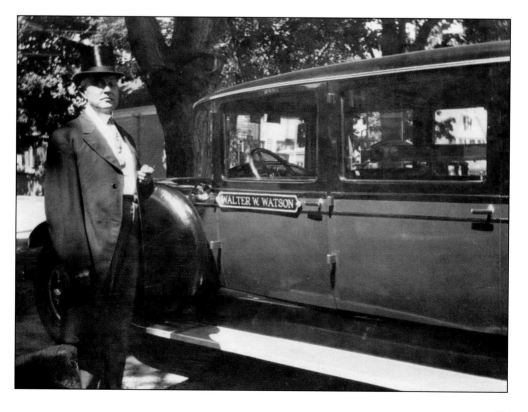

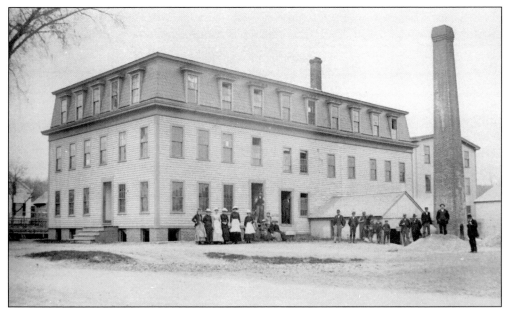

The Spaulding Straw Shop was established by Benjamin Spaulding in the 1860s on the corner of Pearl and Lincoln Streets. It employed up to 400 people, mostly women. Fire destroyed the building twice, once in 1873 and again in 1890. The building was struck by lightning in 1924, destroying it by fire for the final time.

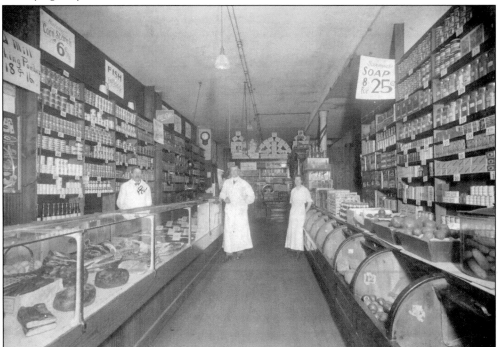

Pictured here in 1915 is the Rockwood Market, which was conveniently located for shoppers on Main Street. Clerks measured and packaged items, truly providing "hands-on" personal service. As farmers in Milford took on industrial work, they began to shift from a more agrarian way of life and started purchasing goods in markets.

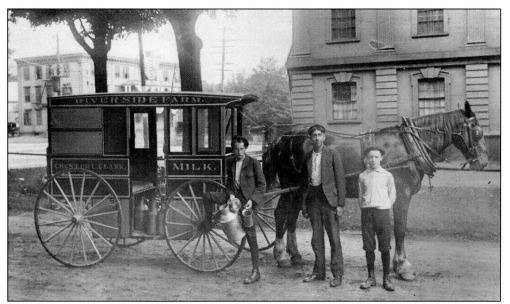

Chester L. Clark ran a large farm at 41 Purchase Street with 400 acres of land. His house, built in 1741 by Caleb Gardner, is still standing today, along with a white picket fence. Clark ran a farm and milk route. This image from around 1900 shows his delivery wagon at the town hall, at 52 Main Street. The Milford House is in the background. (Courtesy of the MTL.)

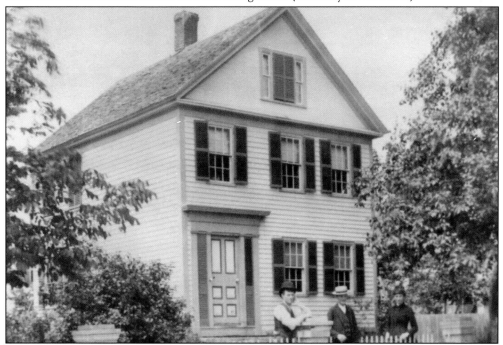

Cornelius and Margaret (Lenihan) Sweeney bought this house at 44 Pearl Street on May 4, 1869. Cornelius ran two markets prior to opening the Pearl Street Market, which was beside their home. Patrick Sweeney followed in his father's footsteps. Later, Cyril Kellett, Cornelius's grandson, took over the market, becoming the third generation to run the business, which operated from about 1860 to 1950.

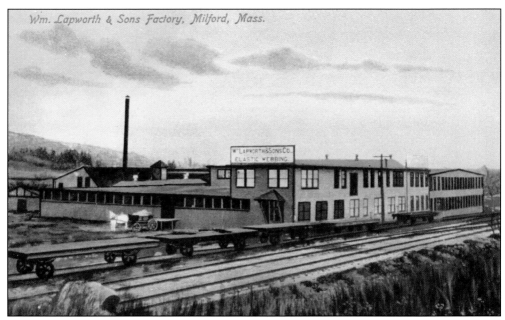

Lapworth & Sons Company manufactured elastic and webbing around the turn of the 20th century. It was located in the rear of the Bickford Shoe Company on Depot Street. The Milford Paper Box Company occupied the building for a while, and it is currently Grandma's Attic, a moving company.

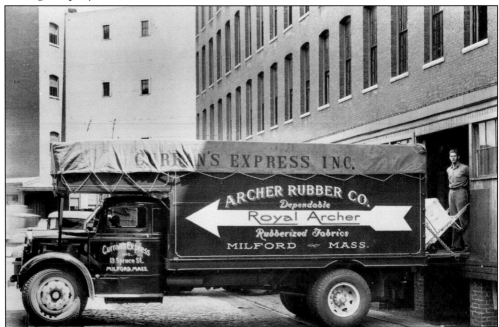

Curran's Express offered daily service to Boston and overnight service to New York around 1930. It had offices in New York, Boston, Framingham, and Milford. Company president John F. Curran's office in Milford was located at 13 Spruce Street, where Rosenfeld's Garage was for many years. Archer Rubber Company has been operating in town for over 100 years. (Courtesy of Paul Curran.)

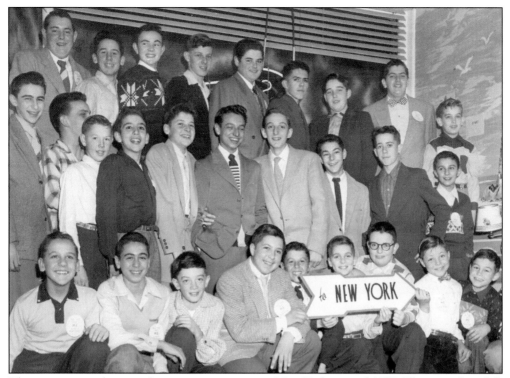

These newspaper boys are hoping to win a trip to New York around 1953. They are, from left to right, (first row) Bernard Lombardi, Jerry Tosches, Michael O'Neil, James Romiglio, Donald Carboni, Joseph DaVita, Joseph Flaherty, unidentified, and George Meade; (second row) Donald Bell, Bento doCurral, Keneth Evans, Charles Laquidara, Gerald Hennessey, Anthony Leite, John Tessicini, Paul Innis, Robert Hickey, and Samuel Calgione; (third row) unidentified, unidentified, David Hayes, Richard Taylor, unidentified, Fredrick Cahill, Richard Maloney, Joseph Mazzini, and David Schiappi. (Courtesy of the MTL.)

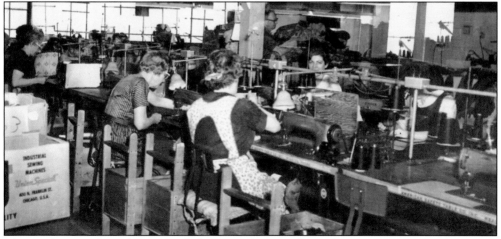

The Anthony Roberts factory made ladies' and men's all-weather coats. It was first located at 7–9 Lincoln Street and later moved to Sumner Street. The factory and showroom offered top-quality coats. This photograph of seamstresses was taken around 1955. The factory is no longer in existence, but Sumner Street is still home to various industries.

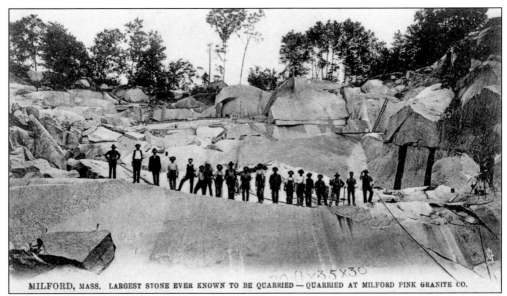

MILFORD, MASS. LARGEST STONE EVER KNOWN TO BE QUARRIED — QUARRIED AT MILFORD PINK GRANITE CO.

Milford pink granite was discovered around 1870 by the Sherman brothers, and the granite business was soon booming, with granite quarried and shipped across the country for use in buildings, monuments, and bridges. Over 1,000 men worked in the quarries by 1900. Today, Milford pink granite can be found in buildings in Milford and Hopedale, as well as in Boston, Washington, DC, New York, Ohio, California, and elsewhere.

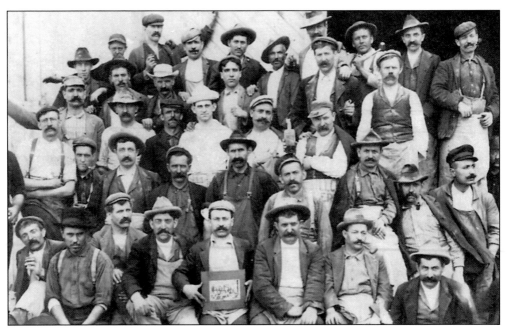

Pictured here around 1895 is a group of quarrymen who cut the stone at the ledge holes and shaped the stone in the cutting sheds. Other men constructed the buildings once the stone reached its destination. Men of different nationalities—notably Italian, Irish, Swedish, and Armenian—came together to build the magnificent granite structures that still stand today.

At one time, Peter Ross owned 300 acres of quarry land on Cedar Street, which later became known as Fletcher's Quarry. Massive columns of granite were quarried, sold, and shipped for buildings in Washington, DC, New York, and Chicago. (Courtesy of Dan Malloy.)

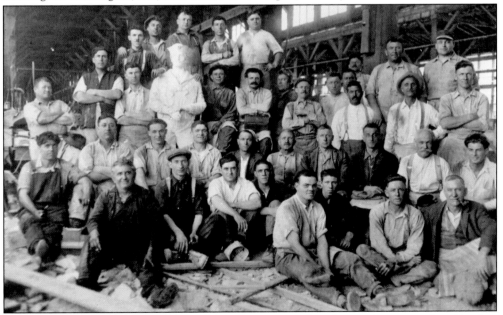

Stonecutters at Dodds Quarry on East Main Street are gathered around a statue of a sailor that was carved in the cutting shed. Monuments such as this still stand today in honor of veterans, a testament to the fine workmanship of these men and the beauty of Milford pink granite.

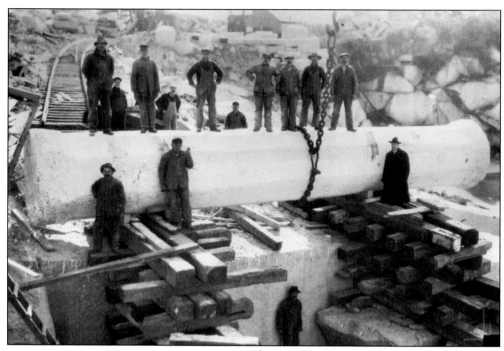

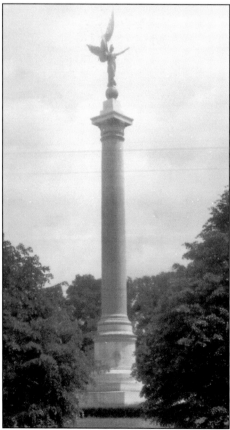

The First Division Monument in Washington, DC, came from Dodds Quarry on East Main Street in 1924. The column was 42 feet long when it was originally quarried, and it required two freight cars fastened together to transport it. E.C. Dodds, vice president, is the gentleman in the topcoat on the far right. (Courtesy of Robin Philbin.)

The First Division Monument in Washington, DC, features a beautiful Milford pink granite column with Daniel Chester French's *Victory* on top. It was unveiled on October 1924 in President's Park, near the Executive Building. The monument was erected following World War I to honor the more than 10,000 American soldiers killed in combat. (Courtesy of Robin Philbin.)

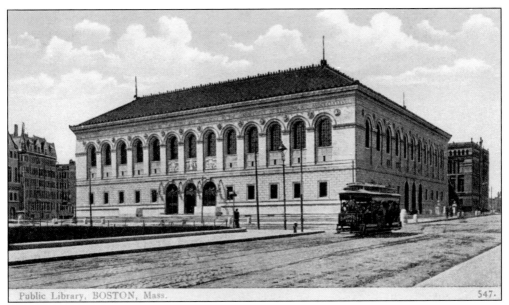

The Boston Public Library was one of the most notable architectural monuments of its day. Located in Copley Square and designed by Charles Follen McKim, it was built of Milford pink granite in 1895. There are many other significant structures built of Milford pink granite, including the Old John Hancock Building in Boston, the original Penn Station in New York (demolished in 1963), and Grand Central Terminal in New York.

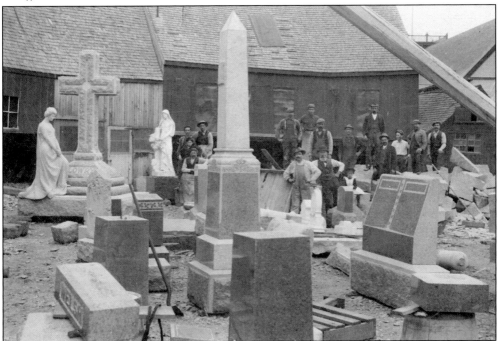

The Milford Monumental Granite Works was located off of East Main Street at 6 Cedar Street. It was owned and operated by Pietro Revolti. The skilled work of stonecutters made these impressive monuments, gravestones, and religious statues possible. Today, Thomas Delfanti of Milford owns the Whitinsville Monumental Works and is a third-generation stoneworker.

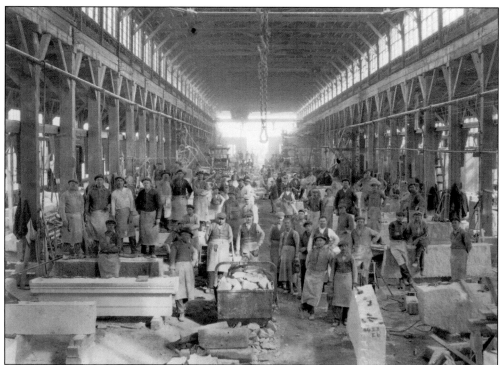

Milford Pink Granite Company was one of several granite companies that put Milford on the map. The stone was recognized for its beauty and quality. The photograph above was taken inside a cutting shed, where stone was cut to order and skillful men shaped the rough stone into artful monuments. Below is a busy quarry yard, with the cutting shed, the office, the tall smokestack, and the train on the spur track that carried granite inside the shed. (Both, courtesy of Robin Philbin.)

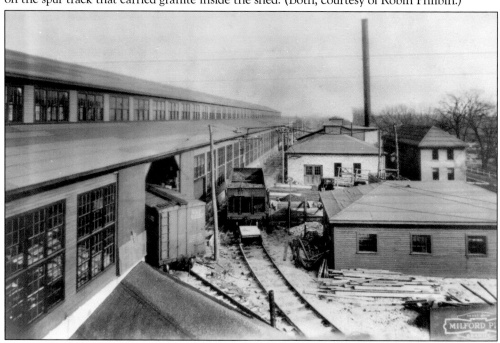

Blacksmiths at the Milford Pink Granite Company are seen here around 1890. They are, from left to right, (first row) Jack Shea (tool boy) and unidentified; (second row) unidentified, unidentified, Joseph Ozella (tool boy), ? Weaver, Herbert Sherman, ? Fino, and unidentified; (third row) Fred Beattie, Waldo Sherman, James Donahue, Percy Weaver, ? Tognazzi, ? Mathewson, and four unidentified men.

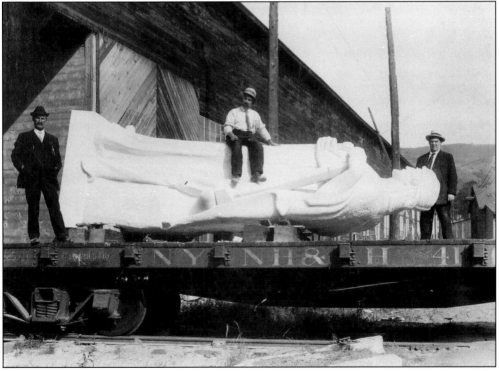

This monumental statue of Milford pink granite is shown on a freight train on the New York, New Haven & Hartford line. Edward "Gaffa" King, a superintendent who was later an owner of a quarry, is presumably the gentleman pictured on the right. Milford pink granite is famous for being sought after for buildings and monuments across the country. (Courtesy of the MTL.)

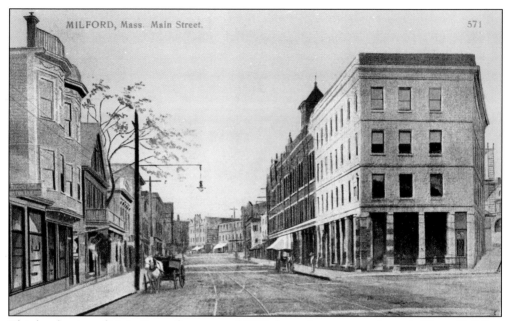

This lovely view of Main Street from around 1895 shows the strong and stately Thom Building on the right. Built by Scottish stonecutter James Thom in 1891 of Milford pink granite, it is listed in the National Register of Historic Places. The ground level of the building has hosted several restaurants, including Cobblestones and today's 89 Trattoria.

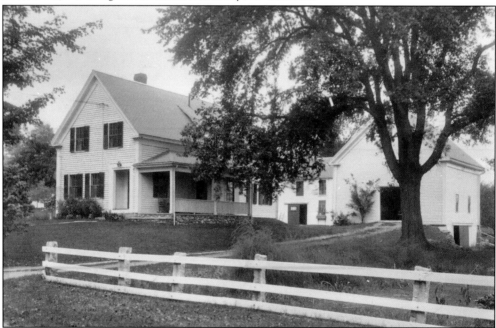

The boot and shoe industry began in Milford in 1795 when Col. Arial Bragg, a custom shoemaker, started making shoes and selling them out of his saddlebag. This house on Adams Street was the home of Bragg's son Mellon. Arial had a shoe shop located between the house and the barn, where hired men worked with him and learned the trade. (Courtesy of the Lamont and Harper family.)

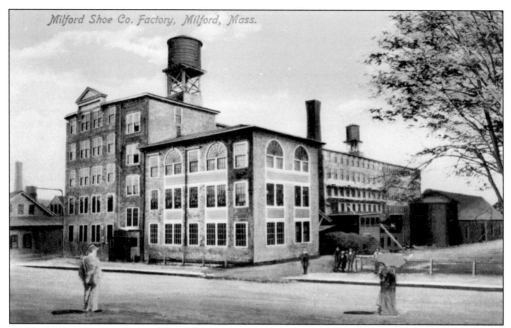

Milford Shoe Company was one of the leading manufacturers of quality men's shoes. This factory was built in 1890 and was one of many shoe shops in town. It was located on the corner of Central and Depot Streets and was razed in 1974. The last local shoe manufacturer to close was Morse Shoe Co., in 1984.

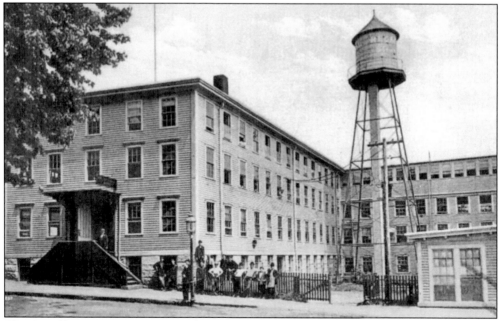

The Carroll, Hixon & Jones Straw Shop was located in this building, followed by Lish Brothers and the Kartiganer Company. Later, it became Regal Shoe before being bought out by Porter Shoe and Milford Shoe Company and operated under the name Little Gents Footwear. The Milford Senior Center is located on the property now.

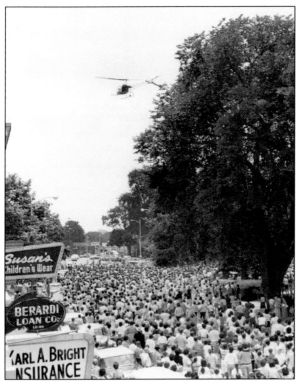

Milford sponsored a "Downtown Sidewalk Sale" around 1960 that brought out a crowd of shoppers. A helicopter dropped Ping-Pong balls with coupons inside that were redeemable at different stores. Some landed on rooftops, creating a bit of frenzy. The Karl A. Bright Insurance Company is still in business today. (Courtesy of Robin Philbin.)

The Werber & Rose clothing and furniture store, located at 107 Main Street, burned in 1962 and later moved to 164 Main Street. The Arcade Block is on the left in this image, and the Thom Building is on the right. Playing at the Ideal Theater was *Man from Del Rio*, starring Anthony Quinn, dating this photograph to 1956. (Courtesy of Robin Philbin.)

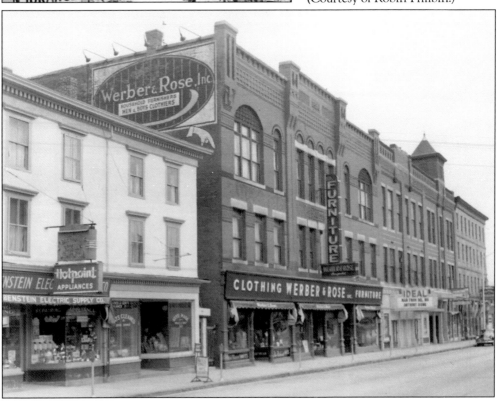

Three

HOUSES OF WORSHIP AND CEMETERIES

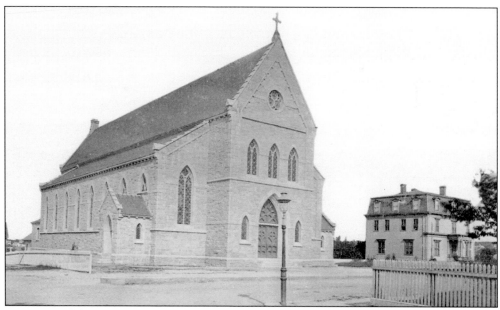

St. Mary's of the Assumption Church on Winter Street is credited to Father Patrick Cuddihy, who was born in Clonmel, County Tipperary, Ireland, on March 17, 1809. He commenced work on the church in 1866 with granite from his own land in the Rocky Woods section, which was hauled by oxen to the church site. It opened its doors on Christmas Day, 1870. A 90-foot tower was added in 1890.

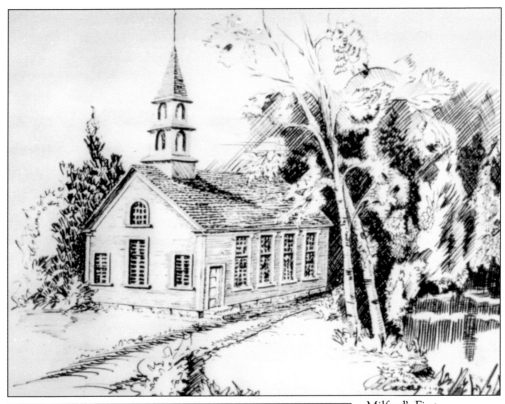

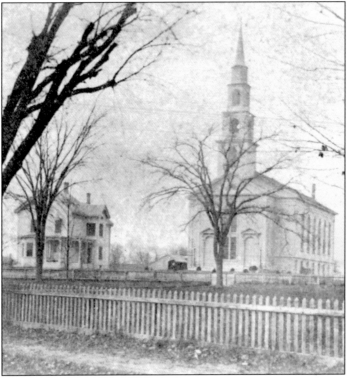

Milford's First Congregational Church (above) was erected on the common (now known as Draper Memorial Park) in 1743, after 26 settlers petitioned to break apart from "Mother Mendon." It was torn down in 1815 to make way for the present church (left), which stands closer to Congress Street. Milford became the "Easterly Precinct" in 1741, and the church was known as the Second Congregational Church until 1780, when the town was incorporated. Today, it is affiliated with the Central Association of the Massachusetts Conference of the United Church of Christ.

Seen here is the First United Methodist Church in Milford, at 42 Exchange Street. The church was dedicated on April 10, 1849. It is the oldest church in Milford still standing on its original foundation. The barn and sheds on the left side of the church are the horse sheds. Methodism first appeared in the North Purchase part of Milford near Camp Street in 1792.

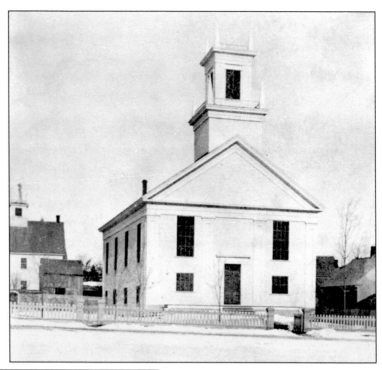

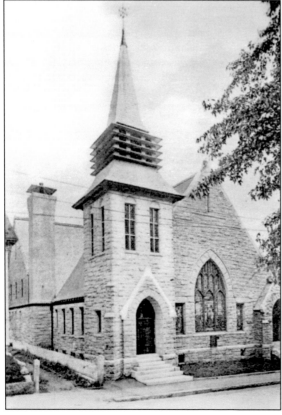

The Universalist Society started in 1781. Over the years, it built three churches. The beautiful Universalist church on Pine Street had its cornerstone laid in 1898. It is made of Milford pink granite and contains memorial windows said to have been made by Louis Comfort Tiffany. The architect was Robert Allen Cook.

39

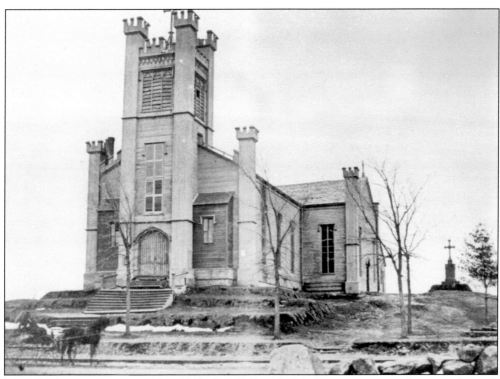

Many Irish immigrants arrived in Milford in 1848 and 1849 due to the potato famine in Ireland. The photograph above shows the first St. Mary's of the Assumption Church, built on East Main Street, with Rev. George Hamilton serving as pastor. In 1863, Father Patrick Cuddihy was sent here to be pastor. He purchased land on Winter Street, where, under his direction, the lovely Gothic Revival church that still stands today was built. The church (below) has a seating capacity of 1,500 people. Father Cuddihy also built St. Mary's School, enlarged the cemetery, and built the Irish Round Tower. Rev. Raymond Goodwin is the current pastor, and the church now serves many nationalities, offering masses in English, Portuguese, and Spanish.

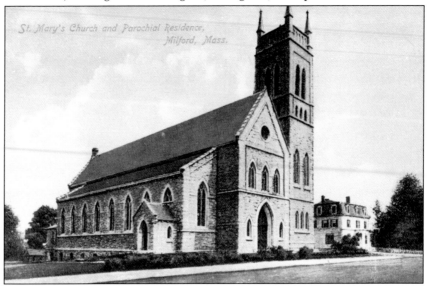

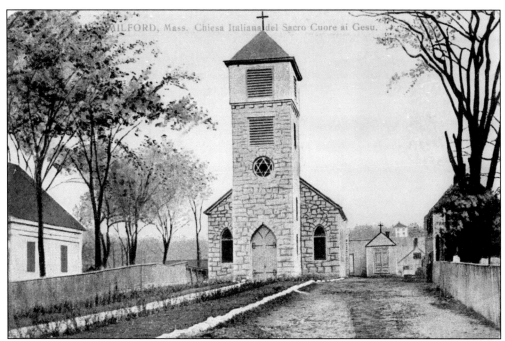

Sacred Heart's second church was built in 1910 and is seen above in its location behind the first church, which was dedicated on August 13, 1905. Sacred Heart Parish started in 1880 when a group of Italian people started meeting together for mass so they could hear it in their native language. The first mass was held at the stone castle on Reade Street in 1890. At right is the beautiful Sacred Heart Church as it appears today, built in the Romanesque Revival style with a beautiful granite staircase. After this lovely church was completed, the parish built a school for eight grades, as well as a convent, a cafeteria, and a clubroom.

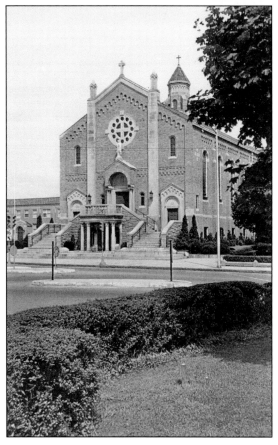

Trinity Episcopal Church was consecrated on March 21, 1871. The land and edifice were paid for by subscriptions, and it cost about $9,000. In 1863, the parishioners had started holding services in the Irving Block, and the church was incorporated the following year. A new steeple was added about 1880.

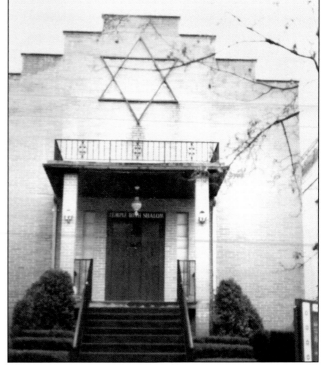

In 1905, a group of 10 Jewish families met and decided to build a synagogue. The cornerstone for the Synagogue Beth Shalom was laid on January 19, 1913, and it was dedicated that September. In 1917, the Jewish community acquired the Tarbell home on Pine Street to be used for social gatherings and as a school for its children to study Hebrew. Rosenfeld Hebrew School was built and dedicated in 1949.

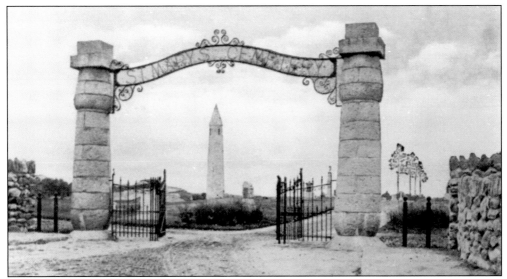

St. Mary's Cemetery is located on Cedar Street. Rev. George Hamilton purchased the first four acres around 1848, and Father Patrick Cuddihy greatly enlarged it. Hamilton Street divides the old section and the new section of the cemetery. Pictured here is the main entrance, adorned with large granite columns, and the Irish Round Tower in the background. The cemetery is enclosed by a lovely stone wall built in 1906 by Patrick Ferguson.

Vernon Grove Cemetery is one of two public cemeteries in Milford. It was established on May 2, 1849, after the stones were removed from the old cemetery, located where Memorial Hall now stands. Most of Milford's town fathers are buried there, but some were moved to the North Purchase Cemetery, St. Mary's Cemetery, and Pine Grove Cemetery.

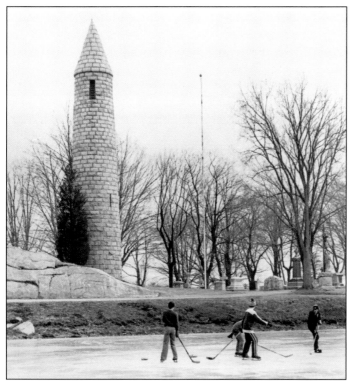

The Irish Round Tower, located in St. Mary's Cemetery on Cedar Street, was built by Father Patrick Cuddihy in 1893. It was constructed of Milford granite and fashioned after the round towers in Ireland, which served as places of refuge during the Viking incursions. This replica is supposedly the only Irish round tower in America. Boys are seen here enjoying a hockey game on the ice-covered pond.

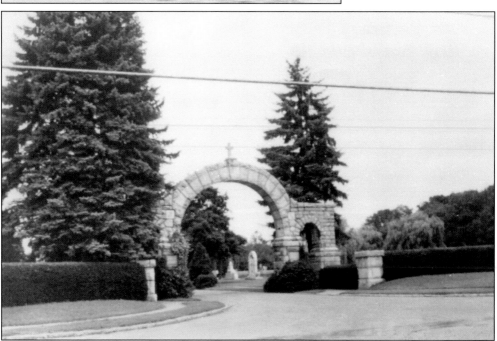

Sacred Heart Parish was granted a charter on May 26, 1937, for the Sacred Heart Cemetery on Medway Road, through the efforts of Rev. Julius Valentinelli. This unique granite arch was designed by the Medway Monumental Company and built by Peter Consigli and Sons of Milford. The large stone cross at the top was placed there by Albert Consigli.

Four

MUNICIPAL SERVICES AND TRANSPORTATION

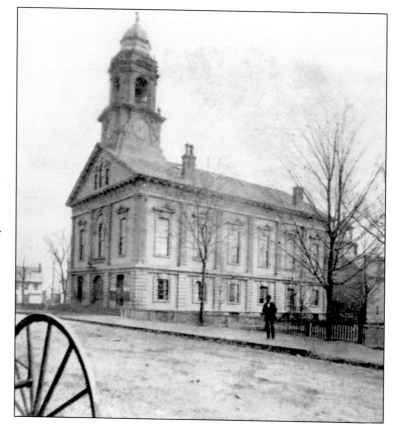

Milford is fortunate to have this lovely old town hall, which is listed in the National Register of Historic Places. The beautiful structure of Renaissance Revival style was designed by Thomas Silloway in 1854, and an addition was added in 1900. Today, it is still the center of government, with town offices located there and town meetings still held in the upper town hall.

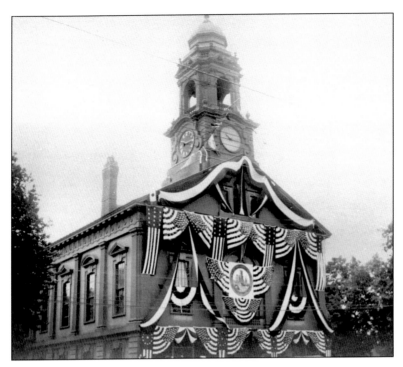

The town hall was designed by architect Thomas W. Silloway in 1854. It is accented with a cupola with an eagle adorning the top. In 1900, town meeting members voted to provide an addition to the building, and Robert Allen Cook, a local architect, skillfully completed the project. The town hall is seen here decorated to celebrate Milford's 150th anniversary in 1930.

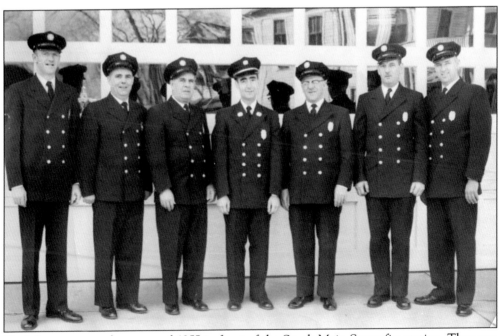

Firefighters are seen here around 1955 in front of the South Main Street fire station. They are, from left to right, John Murray, Peter Costanza, John Sherillo, Lt. Anthony Rossetti, Anthony Visconti, Ronald Mann, and Ernest "Ted" O'Brien. Rossetti was later appointed fire chief. (Courtesy of the Milford Fire Department.)

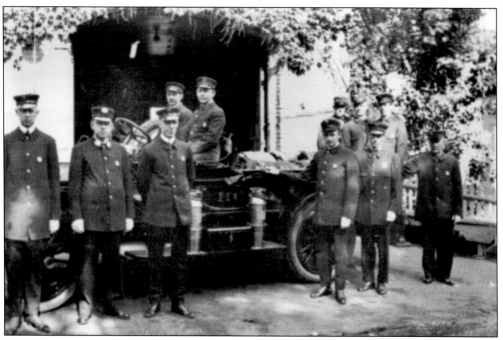

These firefighters are pictured at the South Main Street fire station in 1922. From left to right are (first row) Harry Webber, J. Harry Egan, Chief John J. Maloney, John Walpole, Henry Pyne, Jack Droney; (second row) Sed Chapman, Carroll Dewing, D.E. O'Connor, Leo Murphy, and Charles Joslin. Recently, this fire station was sold by the town to a private party.

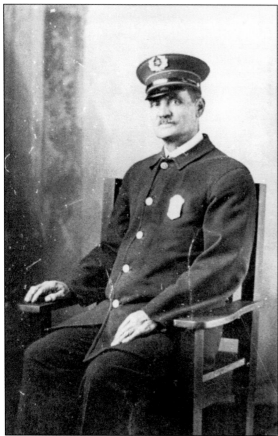

Charles Caruso was the first native of Italy appointed to the police force, on May 4, 1893. He served as a policeman for 32 years. He was also one of the founders of the Sacred Heart Church, and he designed the Doughboy Monument in Calzone Park.

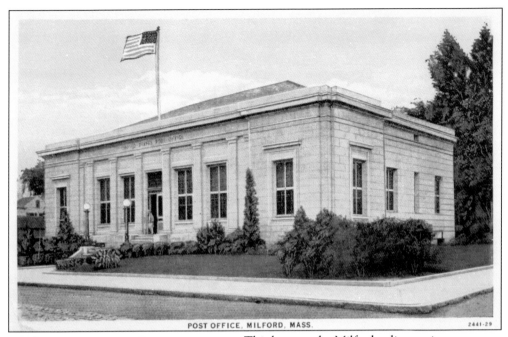

POST OFFICE, MILFORD, MASS. 2441-29

This became the Milford police station in 1967, when the police department was moved from the town hall to its present location at 250 Main Street. The structure was built as the Milford Post Office in 1912 using Milford pink granite. Rufus Pond sold the first stamp on December 7, 1914.

Officer Joseph Nigro, born in 1917, was appointed to the Milford Police Department on May 3, 1953. He served as an officer until his retirement on March 14, 1981. In this photograph, he is standing on East Main Street around 1965. He was a veteran of World War II and passed away in 2008.

Sgt. Walter F. Conley was shot and killed during a robbery attempt while escorting a bank employee returning from a bank across the street on December 10, 1980. Sergeant Conley had served on the Milford police force for 30 years. He was lovingly known as "Moose" Conley. The assailants were arrested in New York State.

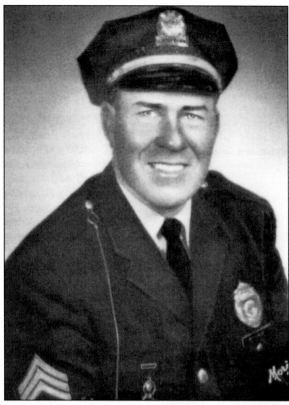

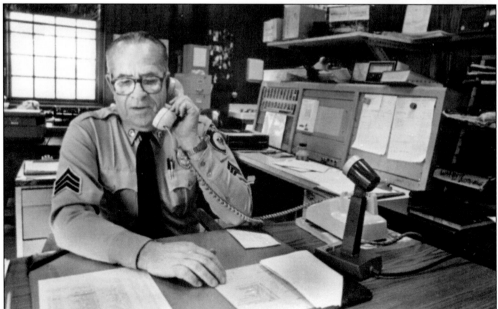

Sgt. Donald Small is pictured here at the dispatch desk inside the Milford Police Station. He was appointed as a police officer on November 14, 1950, made a sergeant in April 1968, and then made acting chief. He retired from the force in April 1985. The station is located at 250 Main Street in a building that was formerly the post office, built of Milford pink granite.

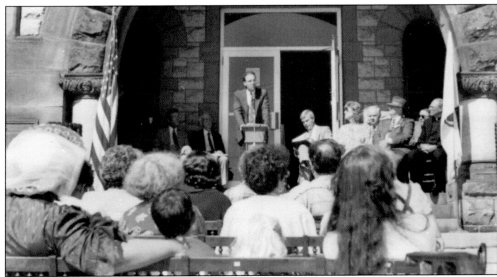

Memorial Hall's 110th anniversary celebration was held on September 9–10, 1994. It was sponsored by the Memorial Hall Cultural Center, Inc., and the Milford Historical Commission. Architect Fred Swasey designed the building, which honors Civil War soldiers and sailors. From left to right are Sen. Louis Bertonazzi; Dominick D'Alessandro; Brian Murray, Esq.; town moderator Michael Noferi, Esq.; Rep. Marie Parente; town accountant John Pyne Jr.; Arlen Johnson, Esq.; unidentified, and Rev. Michael Foley.

The Milford Town Library's reference room is pictured here around 1960. Encyclopedias were located in rooms similar to this in libraries across the country, where students did research for homework and projects. The library was located in Memorial Hall on School Street for over 100 years, until the new library opened its doors in 1986 on Spruce Street.

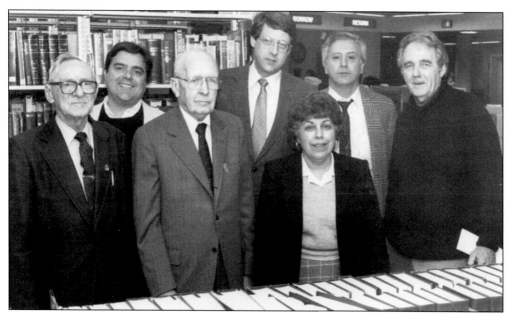

The board of trustees for the newly built Milford Town Library includes, from left to right, Emilio Pighetti, Edward Bertorelli, Paul Raftery, Dr. Richard Heller, Mary Ann Desena, Ronald Longobardi, and Paul Curran. Desena was the first woman elected to serve as a trustee in the 122-year history of the library. Pighetti served until he was in his 90s.

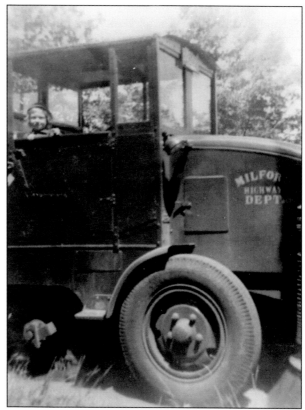

The Milford Highway Department is represented here with an early street sweeper. The small child is Alane Charzenski (Baker), the daughter of former employee Henry Charzenski. The photograph was taken around 1955. The highway department is still busy today, resurfacing roads, replacing sidewalks, removing snow, and picking up leaves. (Courtesy of James Charzenski.)

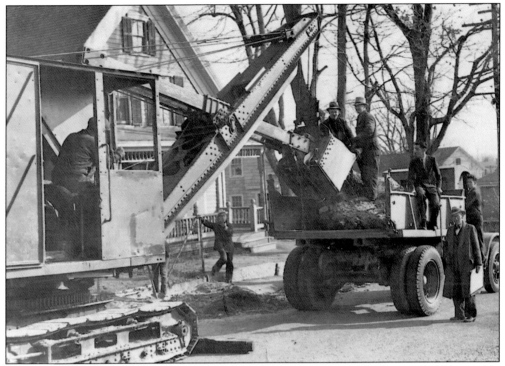

The Milford Highway Department is shown here operating a steam shovel around 1940, possibly on South Bow Street. Steam shovels were used for excavating rock and soil prior to diesel-powered shovels. They were operated by a three-man crew: engineer, fireman, and ground man. Note the Caterpillar tracks. (Courtesy of the Milford Highway Department.)

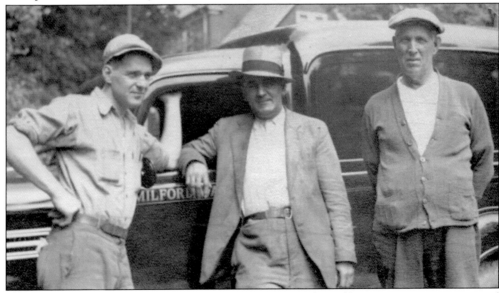

The Milford Water Company was incorporated in 1881. Technical betterments were engineered over the years. William Marshall Sr. (center), the maintenance manager from the 1930s until his death in 1952, is seen here with two unidentified men. Today, the utility is still privately owned and operated.

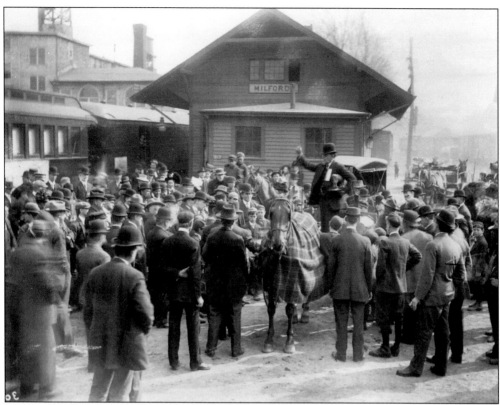

Mr. Harwood, general agent of the state dairy bureau, talks to a crowd of people at the Boston & Albany Railroad in Milford. According to a brochure on the Better Farming Special, the five-car train was in Milford on April 2, 1910. (Courtesy of Historic New England.)

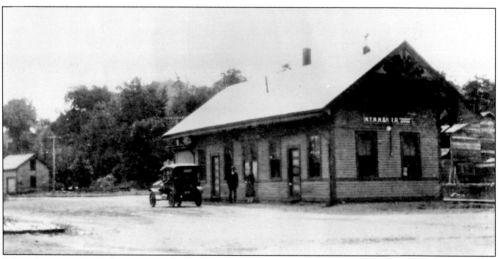

This photograph of the New York, New Haven & Hartford station was taken in the 1930s. The freight house is visible in the background. The arrival of the train changed Milford, making it an industrial town. Passengers and freight could be transported easily to Boston and New York. (Courtesy of Pat Fahey.)

Steamer No. 2 is seen here on South Main Street around 1908. From left to right are William Ahearn, William Fairbanks, and George Dudley. This steamer was probably used for the most tragic fire in Milford, which occurred in 1914 when 11 people died as the result of a fire in the Armenian boardinghouse on West Street. (Courtesy of the Milford Fire Department.)

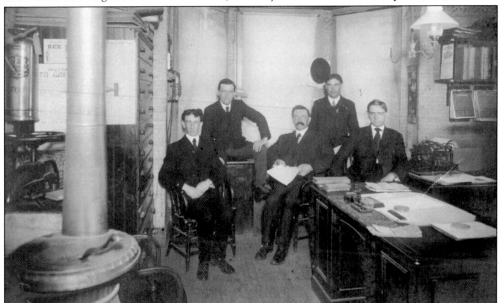

This photograph was taken inside a train depot on Central Street, where passengers boarded the train for Framingham and Boston. George Cadman is seated at the far right in the 1904 photograph. Passenger trains no longer leave Milford, but a freight train does go to the Verallia Glass Company on Depot Street.

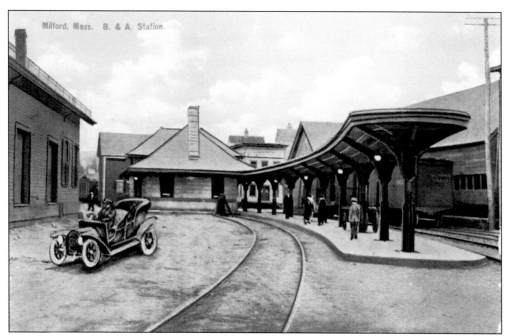

The granite train depot on Central Street was erected in 1909 at a cost of $20,000 by the J.W. Bishop Company of Boston under the supervision of Edward "Gaffa" King. The granite was taken from the Webb Granite Company, off of Dilla Street. The station ceased passenger operations in 1959 and freight operations in 1974. (Courtesy of Robert Holmes.)

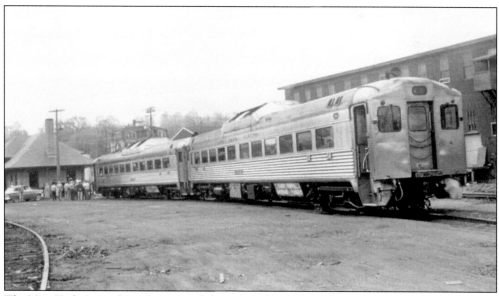

The New York Central Bee line passed through Milford's depot on April 27, 1958, with the Mass Bay Railroad enthusiasts on board for a "Milford Migration" trip from Boston. The depot is now the Countryside Discount Liquor Store, at 170 Central Street. (Courtesy of Pat Fahey.)

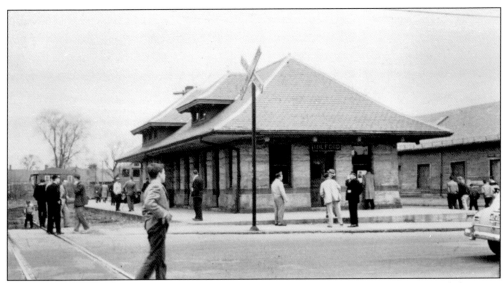

This is the Boston & Albany train depot on Central Street, where passengers boarded the train for Framingham and Boston daily. This photograph was probably taken around 1950. (Courtesy of the MTL.)

In 1931, these four Milfordians pose in front of the Cedar Street Garage, at 106 Main Street. From left to right are Louis Bagaglio, who worked at the station; Batista Brogioli, a friend; Santo Bagaglio, the owner and a stonecutter; and George Bagaglio, the gas and oil specialist. Later, this garage became Zampino's gas station.

Five

Parks, Military, and Organizations

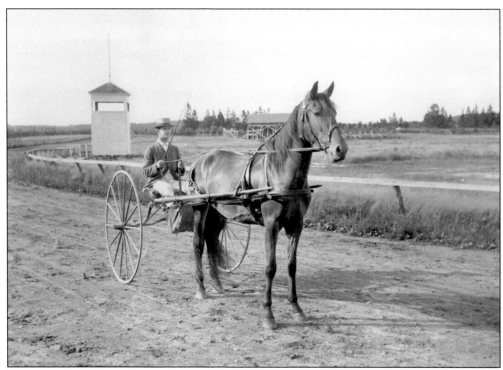

This photograph was taken at the Charles River Driving Park, located on Cedar Street. Here, Victor is being driven by Fred L Mead. On August 10, 1882, James Thom conducted a five-day light harness racing meet at the park. It was one of the biggest sporting attractions ever held in the area. Featured was Nelson, the world's fastest trotting stallion, who trotted an exhibition mile in two minutes and 19 1/4 seconds.

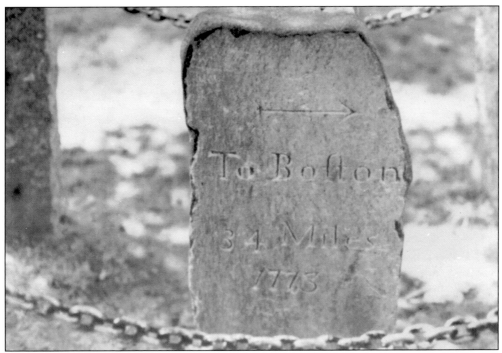

In 1975, the Milford Antickers Club and Earle Johnson placed Milford's milestone in Draper Memorial Park. They had found it in the dump. This stone was first placed at the intersection of South Main and Main Streets. It later became the steps for Ides' Blacksmith Shop, at the corner of Water and Main Streets.

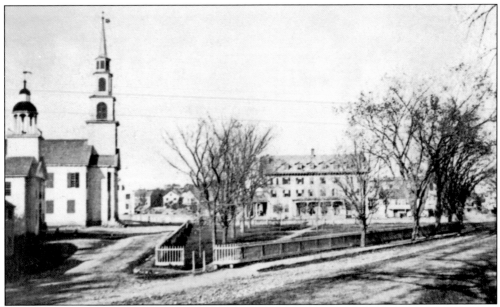

This is an early image of upper Main Street, with a view looking at the old academy, the Congregational church, and the Mansion House. The picket fence was there to keep animals out of the park. The academy was moved to Green Street, and the Mansion House is long gone. B.D. Godfrey reportedly planted the elm trees along Main Street.

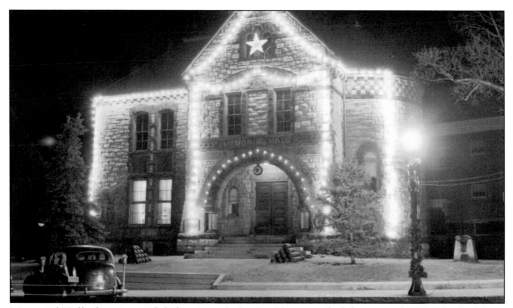

Memorial Hall, glittering with lights, is ready for the Christmas holiday around 1950. This building, located at 30 School Street, is the "jewel" of Milford. The first floor served as the library for over 100 years, the second floor was used by the Grand Army of the Republic and the American Legion as a meeting hall, and the third floor was a banquet hall where oyster dinners and ham and beans suppers were often enjoyed. (Courtesy of Ronald Marino.)

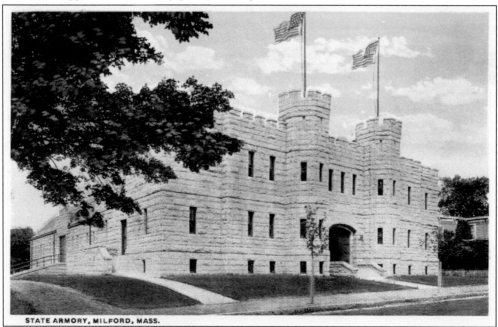

STATE ARMORY, MILFORD, MASS.

John F. Keating of Westboro got the contract to construct the armory on Pearl Street. It was built of Milford pink granite selected from Ardolino's Quarry on East Main Street. The state paid the entire cost of $50,000. Dedication of the building took place on the evening of May 3, 1912. It was the headquarters for the National Guard for almost 100 years and is now the Milford Youth Center.

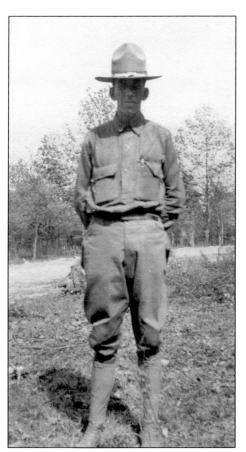

George Aldrich is seen here at Camp Devens on May 19, 1918. He served in World War I. Two letters that he sent home from France are held in Memorial Hall. In April 1917, officers and members of Company M left Milford amid a big demonstration for war duty. A celebration was held to commemorate the signing of the armistice on November 11, 1918.

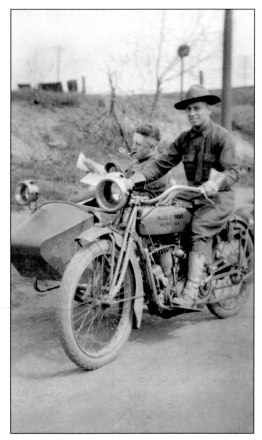

John "Punk" Manuel (right) is seen here on his motorcycle during World War I. Manuel was the commander of the American Legion for many years and helped organize the Legion baseball team.

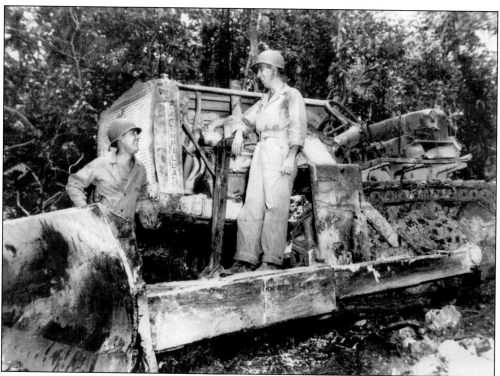

Pictured here are Lt. Charles E. Turnbull (left) and Machinist Mate 1c. Aureolio Tassone. They are with a construction unit at an unknown location during World War II.

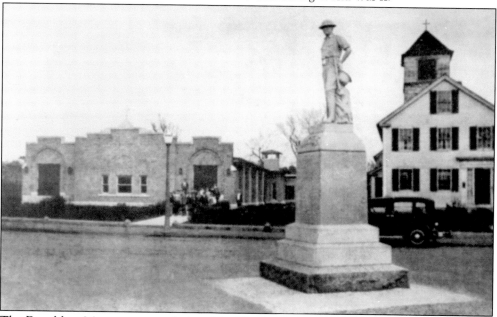

The Doughboy Monument was designed by Charles Caruso and cut by Vincent Cozzi in the monument yard owned by Monti & Rossi. The soldier is made from granite from Westerly, Rhode Island, and stands on a pedestal of Milford pink granite. At one time, the monument stood in the middle of the intersection known as Supple Square. It was later moved to Calzone Park.

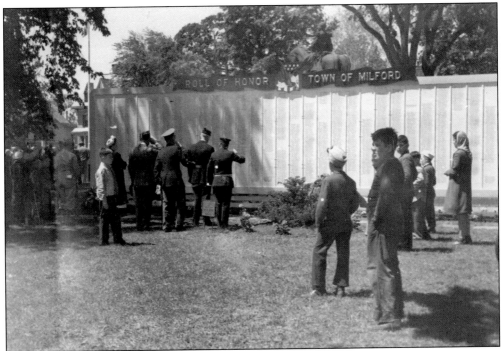

Pictured here on Memorial Day in 1946 is a wooden honor roll of local World War I veterans located in Draper Park. It was replaced with the Milford pink granite monument after it had fallen into disrepair.

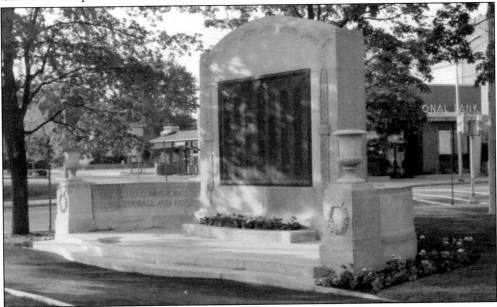

The World War I Memorial is an architectural monument of Milford pink granite with bronze tablets listing men who served in the war. It is located in Draper Memorial Park and was designed by Milford architects Robert Allan Cook and Wendell Phillips, working under a Works Progress Administration (WPA) grant at the Monti & Rossi yard. The memorial was dedicated on Armistice Day, November 11, 1939.

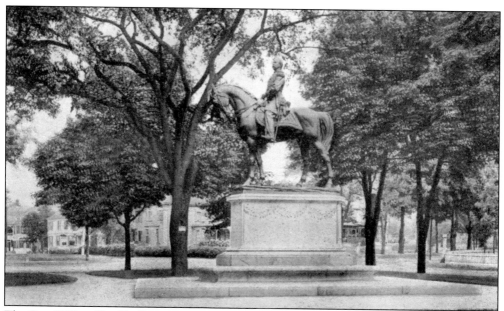

The *Gen. William Franklin Draper* statue, a gift to the town by Susan Preston Draper, was dedicated on September 23, 1912. Draper enlisted in the 25th Massachusetts Regiment at the age of 19 in September 1861 and served in nearly all the Southern states. The statue is the work of sculptor Daniel Chester French, and the pedestal was designed by landscape architect Henry Bacon.

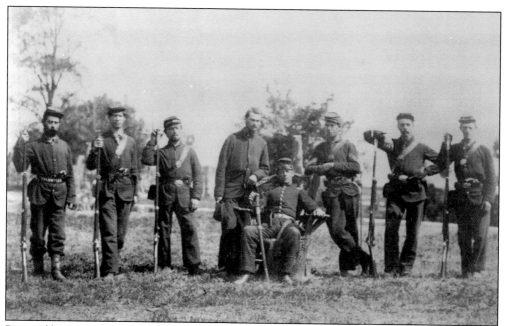

Pictured here are eight of the fifteen members of the "Wide Awake Hose Company," who enlisted in the 40th Mozart, New York Volunteers, Company G. From left to right are William F. Stanley, J.M. Greene, George O. Parkhurst, William B. Drake, Harrison T. Walcott (seated), George C. Sawyer, William T. Holbrook, and Alfred W. Walcott.

The Milford Light Infantry sponsored a supper and dance on February 17, 1892. Programs like this, where people wrote with whom they danced, were common. This was probably held in the Grand Army of the Republic (GAR) hall, upstairs in Memorial Hall. Encampments and dances were held there with visiting posts; in turn, members of the Fletcher Post visited other GAR halls.

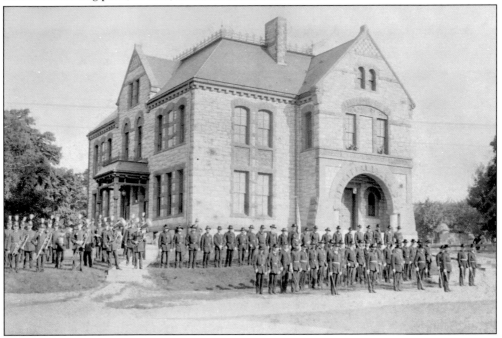

Members of the Grand Army of the Republic, along with their marching band, seen on the left, pose in front of Memorial Hall. They are ready for the parade held on July 4, 1887. Memorial Hall was built in 1884 as a monument for local Civil War veterans. (Courtesy of the MTL.)

The Civil War soldiers pictured here are, from left to right, (first row) unidentified, John Bennett, ? Clark, and G.E. Thayer; (second row) John Barrett, Fred Wilcox, Will Knight, and unidentified. Tablets in the vestibule of Memorial Hall list the names of the Milford men who fought in the Civil War and the Spanish-American War.

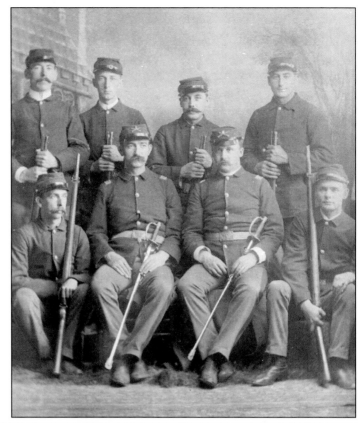

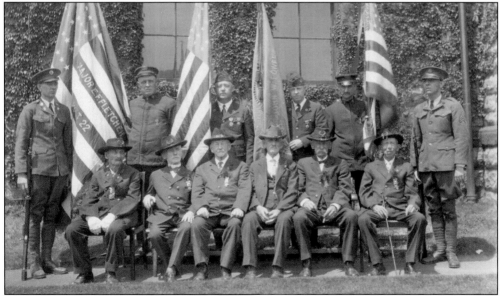

These veterans pose for a photograph on Memorial Day in 1929. From left to right are (first row) George Christian, William Callahan, Herbert Parkhurst, James Fletcher, Frank Taft, and George C. Buck; (second row) Cpl. ? Earle, C.H. Messom, John J. Best, William H. Cahill, C.J. Spearance, and Sgt. ? Boyd.

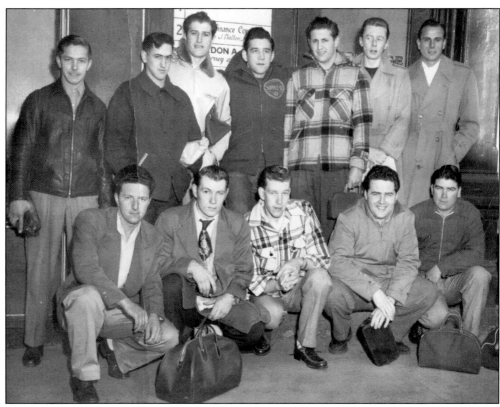

These young men were drafted, and this photograph was taken the day before they left to serve in the Korean War. From left to right are (first row) Joseph DiGiacomo, Albert Winn, Herbert Hackenson, Paul Curran, and Donald Fafard; (second row) Russell Phipps, Wilfred Cote, John Tusino, Eugene Pantano, John Evanoff, John Murphy, and Vincent DeIseo. (Courtesy of Paul Curran.)

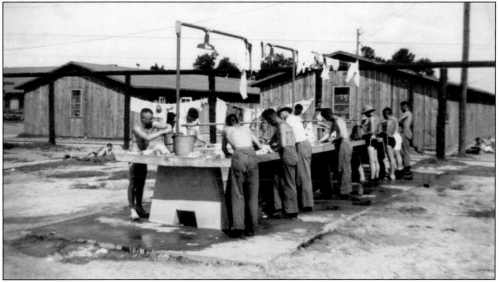

Pictured here at Fort Devens in Ayer, Massachusetts, around 1942 are the Milford boys doing their weekly laundry. This photograph was given to the Milford Historical Museum by Joe DeSantis.

These World War II soldiers are (seated) Arthur Fertitta and (standing, from left to right) Larry Heron, Michael Volpicelli, and David Rubenstein, who was killed in action. Heron, who was seriously wounded in the war, had Chapter No. 6 of the Disabled American Veterans of Milford dedicated in his name. A true hero, Lawrence J. Heron passed away in 1995.

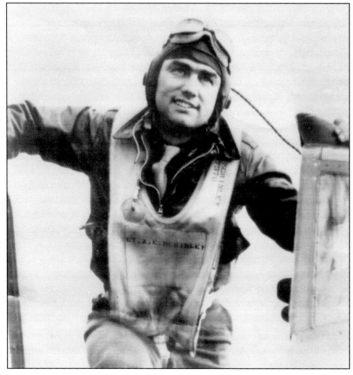

Seen here is Lt. Albert E. McKinley, who was born on July 15, 1920, to Arthur and Effie McKinley. Lieutenant McKinley died over Belgium on Christmas Eve, 1944. He served in the 9th Air Force Division and was a graduate of the Milford High School class of 1938.

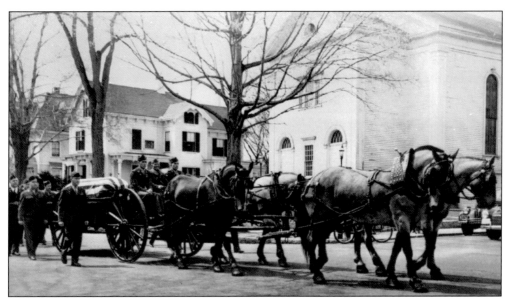

Cpl. David H. Rubenstein's funeral cortege is seen here as it passes by the Congregational church, coming from Main Street after leaving the state armory. He was the first soldier brought home after World War II. He was killed in France on July 4, 1944, and brought home for burial in 1948.

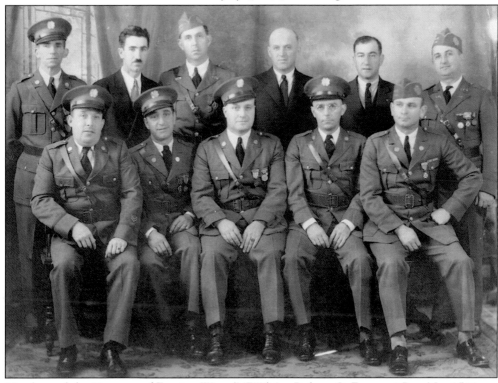

Members of the Veterans of Foreign Wars (VFW) Lt. Robert C. Frascotti Post No. 1544 are pictured here. They are, from left to right, (first row) Emil Moore, "Mush" Manguso, Jessie Peasley, unidentified, and Charles Frascotti; (second row) Arthur Dion, Guy D'Amelio, William Cavazza, Joseph Garbana, "Yarmo" Santoro, and Charles Goucher.

Cyril F. Kellett Jr., MD, of Milford was a commander and medical surgeon in the Navy stationed in Vietnam. In 1968, when he was 32 years old, he was the senior surgeon at Delta Medical Company, located near the Marine supply base at Dong Ha. Later, he was a plastic surgeon at Tri-City Medical Center in Oceanside, California, where he was on the board of directors. (Courtesy of the Kellett family.)

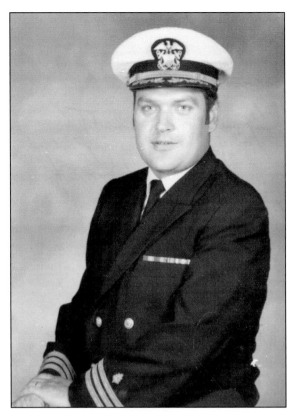

The Milford Elks lodge purchased this house that was originally built for Otis Thayer around 1851. The Elks are no longer there, and it is now the Milford Common Professional Building, which provides space for several doctors, a jeweler, and the WMRC radio station. WMRC started operating in 1956 and keeps Milford up-to-date on happenings in and around the town.

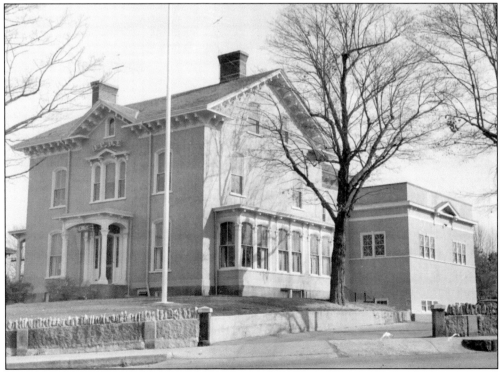

Members of the Antickers Club are pictured here. From left to right are (first row) Doris Gilrane, Doris and Mortimer Dennett, Althea Johnson, and Ruth Ostrand Morey; (second row) unidentified, Louis Benotti, Eleanor Black, ? Webster, and Louise Morey Benotti. This photograph was taken at the Morey home, at 9 Haven Street, in 1948.

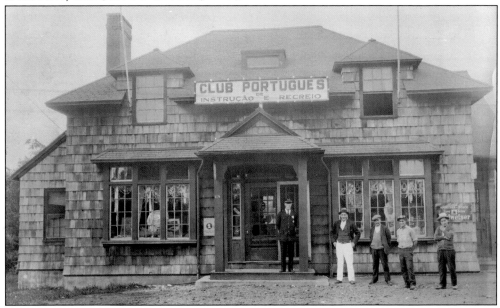

This is an early photograph of the Portuguese Club, located in Prospect Heights. Police chief John Maloney is pictured here with club members after a thief broke the window. This structure was replaced with a new building that has a function room large enough to accommodate 400 people. (Courtesy of Ronald Marino.)

Six

SCHOOLS AND SPORTS

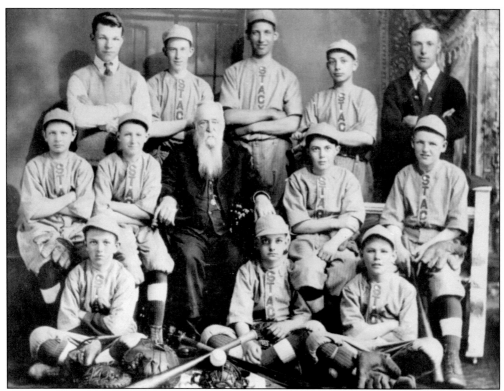

This is the first Stacy baseball team with uniforms, around 1910. Pictured, from left to right, are (first row) Joseph Sheedy, George Irwin, and William Fitzpatrick; (second row) Eugene Bodio, Kelley Whyte, Rev. George Stacy, Thomas Davoren, and Julio D'Agostino; (third row) Ted Steeves, Fred Rose, Roger Gifford, Adam Diorio, and Wilfred "Whisie" Griffin.

The North Purchase District School, built in 1832, remains today just north of Haven Street. The little one-room schoolhouse originally held eight grades and was supported solely by the district for teachers' salaries, building maintenance, and firewood used to heat the school. Eventually, schools became neighborhood schools supported by taxes. This structure ceased operating as a school around 1949 and was a community center for a time.

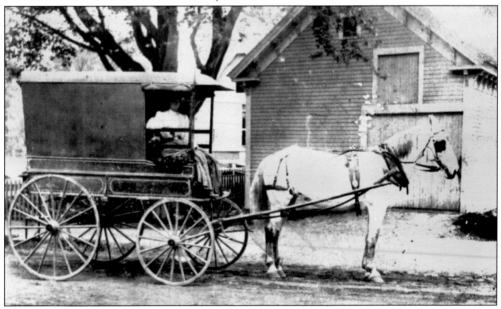

Milford's first school bus is seen here being driven by Phoebe Newton on South Main Street near Dr. French's home. She was on her way to pick up the children who lived too far away to walk to the neighborhood schools. In early years, there were one-room schools, which were later replaced with many two-room schools. By 1904, there were about 17 neighborhood schools.

Milford's first high school, built in 1850, was a beautiful Greek Revival building consisting of four rooms located where Stacy Middle School sits today, facing School Street. It was destroyed by fire of an incendiary nature on March 15, 1900. Everything was lost, including many gifts from graduating classes.

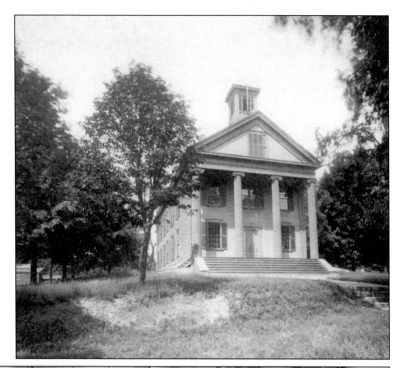

After a performance at the Purchase Street School reunion in the 1920s, the players pose for a group portrait. Helen Bickford (Elliott) is shown kneeling beside her doll carriage. The Purchase Street School was built in 1864 at a cost of $2,607.13. It ran until the 1980s, hosting kindergarten and first grade in the end. Today, it is a day care center.

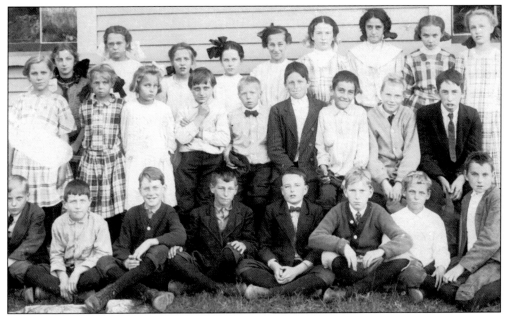

The 1910 students of the Purchase Street School took time off from their studies for this picture. From left to right are (first row) Carl Burpee, Rolf ?, Lee Dalrymple, Thomas Griffith, Frank Murphy, Carl Anderson, Andrew Anderson, and Oscar Williams; (second row) Alma Johnson, Abel Anderson, Earlene (Morey) Cornell, George Rolfe, Nixon ?, George Griffith, George Spindel, Clifford Peterson, and Doc Murphy; (third row) Hazel (Clarridge) Nutter, unidentified, unidentified, Myrtie Kinney, Eva Margaret (Griffith) Dowden, Margaret Murphy, unidentified, Ruth Ostrand, and Rose Morey Johnson.

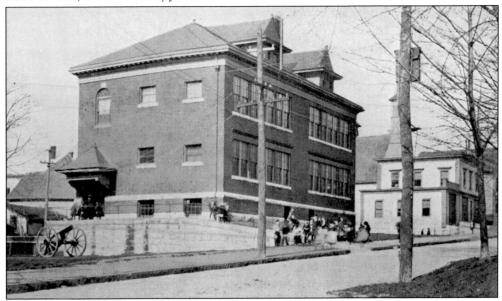

The Spruce Street School, designed by architect Robert Allen Cook, was built in 1895 and torn down after voters approved razing the school in 1983 in order to clear the site for the construction of the new Milford Town Library. Today, the area is very busy, with Stacy School on one side of the street and the library on the other side.

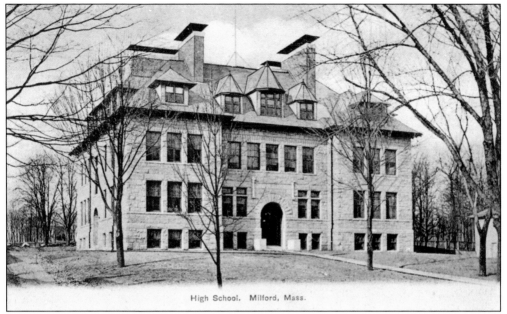

High School. Milford, Mass.

Milford High School was built in 1901 of Milford pink granite. A fire in 1937 caused heavy damage to the building, after which the top floor was removed. In 1973, a new high school was constructed, and this building became Middle School West. In 1995, the building became part of Stacy Middle School. The original Stacy School was built in 1916, and the two schools together make a fine complex.

Students from the North Purchase District School pose for a group portrait in the sunshine. From left to right are (first row) Albert Erickson, Otis Morey, Wilfred Peppin, Fred Lucier, and Ernest Griffith; (second row) Margery Black (Carbonneau), Helen Bickford (Elliott), Veronica Cosetta, Marie Harding, Helen Kasuba, Francis McMullins, and Leonard McMullins.

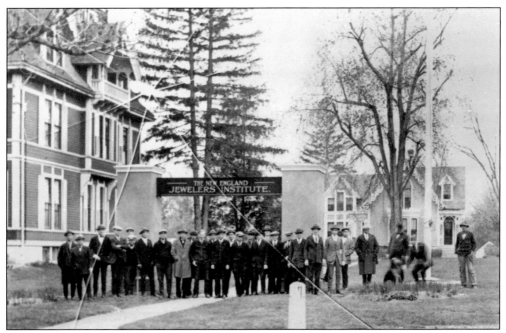

The New England Jewelers Institute, located at 16 Congress Street, was founded on May 21, 1920. This was to become the first jewelers' technical training institute in the United States to train men to repair clocks and watches. The home in the background was built by George H. Johnson in 1869. Johnson was to give the main address for the dedication of Memorial Hall on May 31, 1884, but he died the night before.

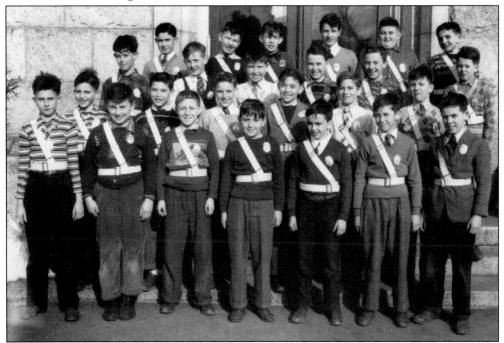

Safety patrol boys stand proudly in front of St. Mary's School around 1950. Students worked as crossing guards years ago, before the town hired adults to do the job. (Courtesy of Paul Curran.)

The Little Engine That Could was written by Mabel Caroline Bragg, who was born in Milford in 1870. Published under the pen name Watty Piper, it is one of the most beloved children's books. She was a professor of education at Boston University and lived in the Braggville section of Milford. (Courtesy of the Paul Curran.)

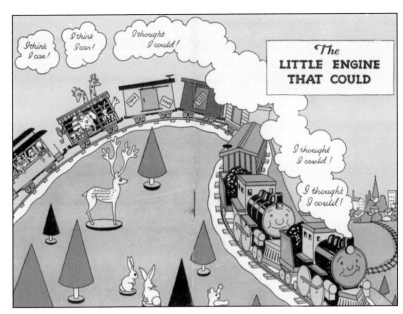

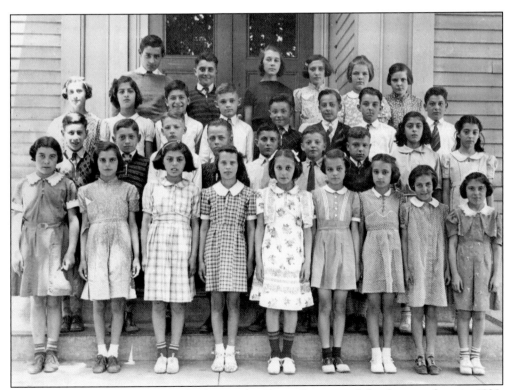

Miss DiGiannantonio's fifth-grade class at the Plains Grammar School is seen here in 1938. Many of the students were first-generation Italian Americans with names such as Pighetti, Grassi, Volpicelli, Piscia, Fratta, Vesperi, Monti, and Luchini. As late as 1952, the Plains was known as the Italian section of Milford. Reunions are still held every summer.

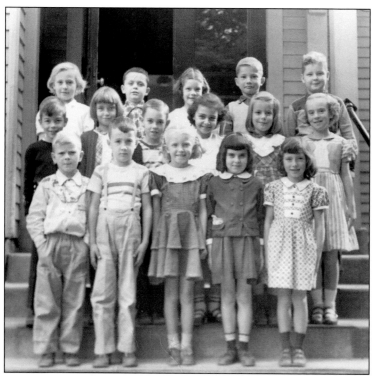

At the Purchase Street Elementary School, the first and second graders pose for their picture on the steps around 1952. From left to right are (first row) Arthur Dunlap, John Oldfield, Anna Johnson, Marilyn Consigli, and Sandra DeBoer (Smith); (second row) James Church, Brenda Nohr, Wayne Walliston, Marcella Marino, Sandra Lague, and Barbara Collins; (third row) Diane Morey, Charles DeMarais, Susanne Elliott (Jenkins), Richard Cenedella, and Robert Jenkins.

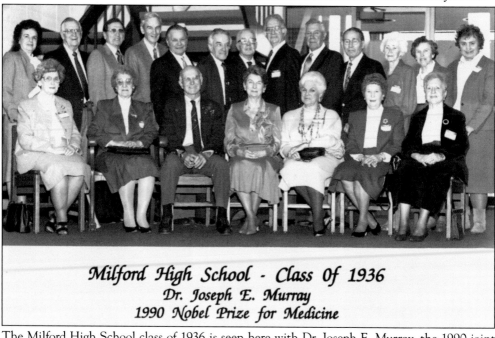

Milford High School - Class Of 1936
Dr. Joseph E. Murray
1990 Nobel Prize for Medicine

The Milford High School class of 1936 is seen here with Dr. Joseph E. Murray, the 1990 joint winner of the Nobel Prize in Physiology or Medicine. He is seated third from the left in the first row. The 2012 Annual Town Report reads, "The Town of Milford proudly recognizes Dr. Murray's accomplishments and awards as well as his genius. We are truly fortunate to have known him and his passing is the world's loss."

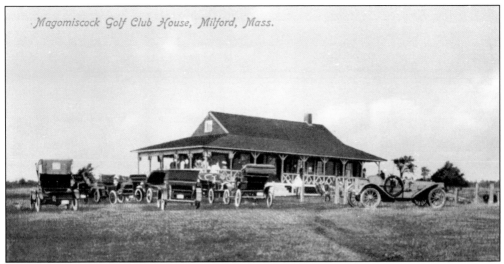

Magomiscock Golf Club House, Milford, Mass.

The Milford Country Club is set on a picturesque hill on Country Club Lane. It was originally called Magomiscock Golf Club when it was first organized, on September 17, 1900, after the Nipmuck word meaning "ground affording a grand view." Today, it is a private nine-hole course with two sets of tees for different skill levels.

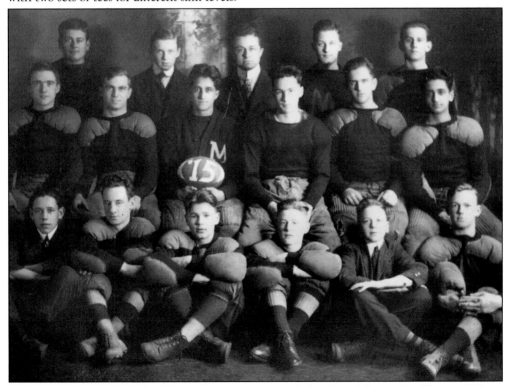

The 1915 Milford High School football team picture includes, from left to right, (first row) Elmer Nelson, John Kelley, Raymond Grayson, James Dalton, Patrick Carr, and George Bruce; (second row) William Sprague, Charles Vesperi, Doc Oliveri, Howard Hilton, George Bruce, and Lou Breeze; (third row) Buck Solari, Francis Hickey, coach Alfred Cenedella, George Larkin, and Henry Nelson.

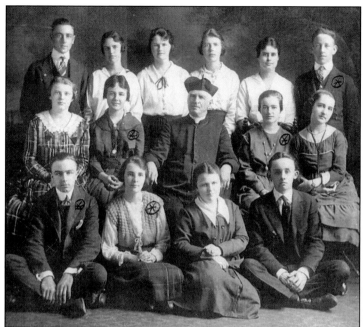

The St. Mary's graduating class of 1919 poses for this photograph with Father David McGrath. The image includes, from left to right, (first row) James Slattery, Anna Scully, Alice Foyle, and Charles McGowan; (second row) Catherine Curtin, Mary Carron, Father McGrath, Ruth Moran, and Regina Curley; (third row) George Fagan, Isabelle McKenna, Helen Callery, Martina Barry, Alma Filbert, and Joseph Casey. (Courtesy of Paul Curran.)

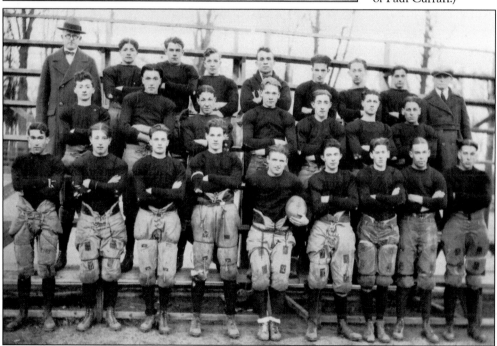

The 1924 Milford High School football team picture includes, from left to right, (first row) Rico Frascotti, Rodney Alzarini, Ted Mitchell, George Pyne, captain Julius D'Agostino, Thomas Davoren, Fitter Cahill, Raymond Adams, and Jack O'Neil; (second row) Albert Shaw, Thomas Quirk, Benjamin Consoletti, Harvey Cough, Lawrence Bowen, Charles Gilmore, and Ernest Lombardi; (third row) Principal Thomas Quirk, Bernard Gardetto, Zeke Turner, William Broderick, coach Albert "Hop" Riopel, Nick Collantonio, Jake Broudy, George Gagliardi, and manager Arthur Vesperi.

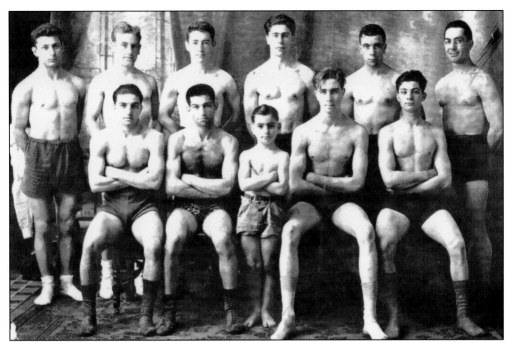

The Milford Boys Club wrestling team members show off their muscles in this 1935 photograph. Pictured are, from left to right, (first row) Joseph Comastra, Martin ?, Michael Diorio, Hubard Chapman, and Louis Diorio; (second row) James Carachino, Francis Powers, Joseph Racine, Patrick Zampino, Alfred Abbondanza, and coach Adam Diorio. (Courtesy of Mark Zampion.)

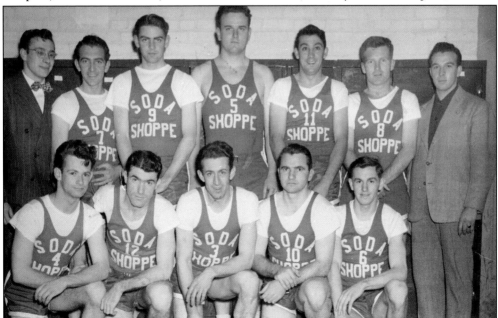

The Soda Shoppe basketball team is pictured here in 1949. From left to right are (first row) Albert "Chick" Sayles, Vincent Dagnese, Joseph Hickey, Anthony Pilla, and Robert Giacomozzi; (second row) unidentified, unidentified, unidentified, Richard Phillips, unidentified, "Red" Oates, and coach Richard Piergustavo.

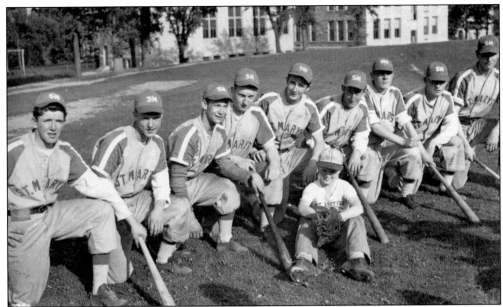

The St. Mary's baseball team poses for this group photograph. The team includes, from left to right, William Casey, unidentified, Mac MacNamara, Albert "Chick" Sayles, Joseph "Red" VonFlaten, James Casey, Joseph Pratt, Armand Desmaris, Red Roche, and Richard Phillips. Seated in front is an unidentified batboy, and first baseman Louis Pagnini was absent that day.

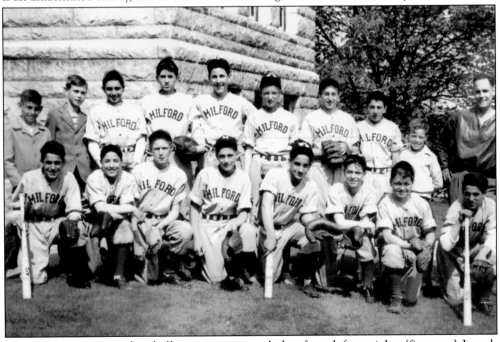

The 1949 Stacy junior baseball team picture includes, from left to right, (first row) Joseph Gandolfi, Joseph Alves, Charles Eden, Matthew Berardi, Robert Pagnini, Joseph Guerino, Glen White, and Frank Gandolfi; (second row) Fred Maffia, Daniel Glennon, Joseph Cimino, Harold Federici, Charles Ramelli, Robert Stoico, Nick Maietta, Anthony Marcello, Leonard Lynch, and coach Charles Espanet.

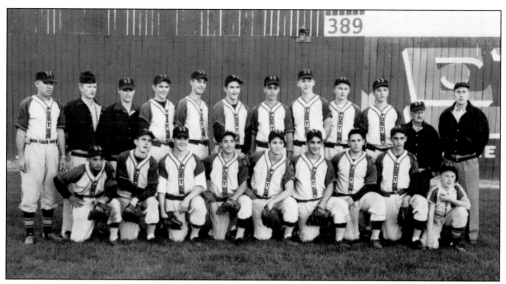

In 1952, the John W. Powers Post No. 59 baseball team played in the national finals in Denver, Colorado. Pictured, from left to right, are (first row) James Marcello, James Norton, Michael Kowowzky, captain Joseph Alves, John Niro, Robert Pagnini, Gardie Rhett, Matthew Beradi, and mascot Joseph Consoletti; (second row) coach Christopher "Pep" Morcone, athletic officer Walter Power, Peter DePaolo, Edward Henneberry, Richard Thebault, Paul Petrosky, Ralph "Lefty" Lumenti, Michael Sherbrook, Leo Cassidy, Robert Stoico, equipment manager Arthur Maynard, and team manager Walter Conley.

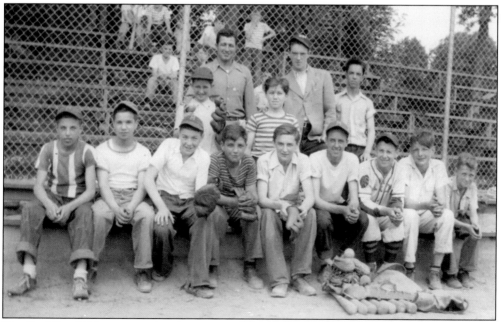

The Red Sox Midgets were the champions of the Milford Boys Club series in 1944. From left to right are (first row) Daniel DeSantis, Johnny Covino, Gerald Barlow, John Verelli, David Tredeau, Arnold (Chuck) Votolato, "Ducky" Sayles, and cocaptains Richard Howarth and Jack Kelly; (second row) Buzzy Lancisi, coach Ernist Roberti, Richard DeCapua, and umpires Thomas Fitzgerald and Edward Ghelli.

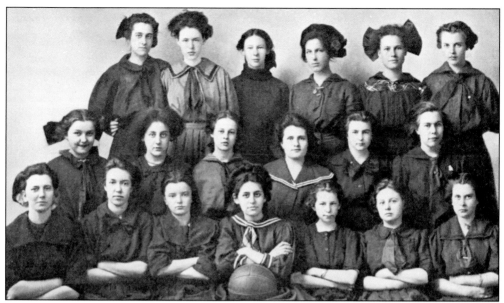

The Milford High School girls' basketball squad, pictured here in April 1911, embodies the motto of the school's yearbook, the *Oak, Lily and Ivy*: "Strength, Purity, Tenacity." From left to right are (first row) Margaret McNamara, Florence Weeks, Daisy Dodge, captain Hilda Williams, Vinnie Woodbury, unidentified, and Beatrice Newcombe; (second row) Sara Haskard, Patrice Dillon, Esther Fuller, Sadie O'Connell, Mildred Carpenter, and unidentified; (third row) unidentified, Margaret Williams, Dorcas Whipple, Emma Russen, Bernice Ferry, and unidentified.

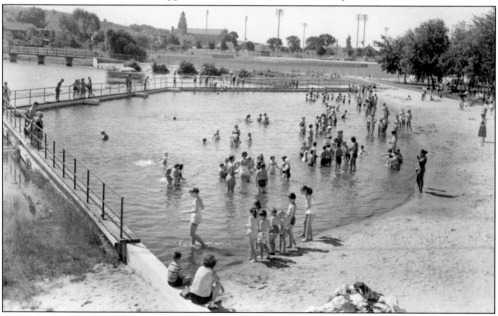

Milford children have been enjoying the large swimming pool at Fino Field since 1957. The Rotary Club has sponsored swimming lessons there for over 50 years. Fino Field was named for Rudolph Fino, who was killed in World War II. It is a popular site for baseball, soccer, and football, as well as walking, now that the Upper Charles Trail goes through the area. (Courtesy of Ronald Marino.)

Seven

HISTORICAL HOMES
AND THE HOSPITAL

George Dwight Underwood built this lovely mansard-roofed home at 33 Walnut Street in 1866. The interior of this home has beautiful woodwork and unique fireplaces. Underwood resided here until 1872, when he moved to Newtonville so he could be closer to his business in Boston. It is now the home of Dr. Nicholas and Charlotte Mastroianni.

Obadiah Wheelock built this home on Howard Street in 1709, and it is the oldest house in Milford. Wheelock was one of the original Mendon proprietors. The house has been owned by the Ferrucci family for several generations and remains a farm. Much of the original structure remains intact. It is also known as Ye Olde Farmhouse.

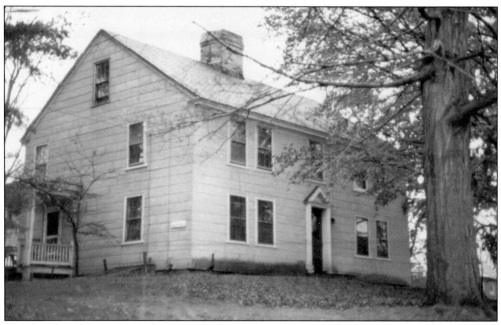

This lovely old Colonial residence at 96 South Main Street, with its center chimney, was built in 1711. It was the home for a 400-acre farm owned by Benjamin Hayward. In later years, it was owned by Nathan Wood, who was one of the proprietors of the Milford Academy. The house was demolished about 1995.

This house was built by Deacon Nathaniel Jones in 1722 at 13 Silver Hill Road. It was moved to 198 Purchase Street in 1878 by George Kibbey. Jones was one of the signers who established Milford as a town. Someone living in this house has served in every American war, including the French and Indian War and the Revolutionary War.

John Jones Jr. built this home on Eben Street in 1723 and later swapped the farm with his brother-in-law Elder Daniel Corbett of Bellingham in 1742. The Jones family and the Corbetts were both early settlers who requested that Milford separate from its "mother" town, Mendon. The restored saltbox home is currently owned by the Caruso family.

The 1747 home above, at 44 Silver Hill Road, is listed in the National Register of Historic Places. It was originally the home of Azariah and Sarah (Jones) Newton. Members of the Emory Sumner family lived in it from 1816 to 1916. Thelma and Arthur Floyd have lived in the historic home, with its large center chimney and five fireplaces, for over 60 years. The photograph below shows the hearth, which would have been used for cooking and heating, along with a foot warmer, a butter churn, andirons, and crocks. Thelma continues to enjoy her home today, which is kept like a museum.

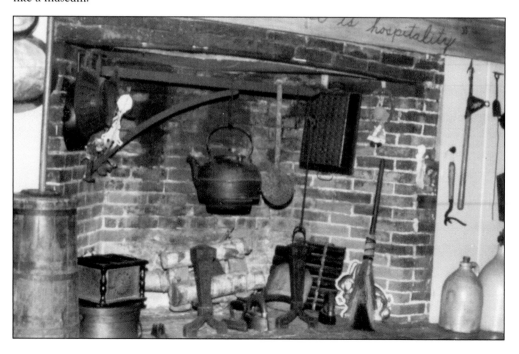

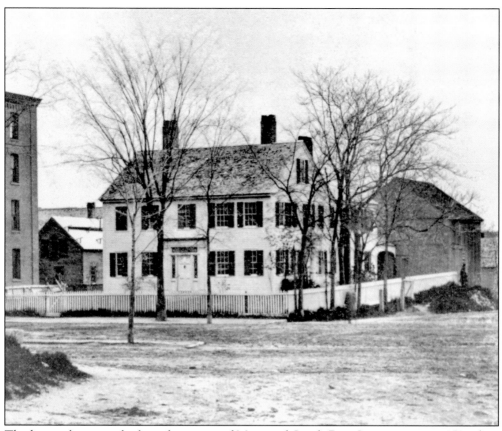

The home above was built at the corner of Main and South Bow Streets prior to 1850, when Main Street had only homes and no businesses. It is now located at 18 South Bow Street. Seen below is the Bank Block, built about 1850, which is now the Milford Federal Savings and Loan Association, although the third floor is no longer there.

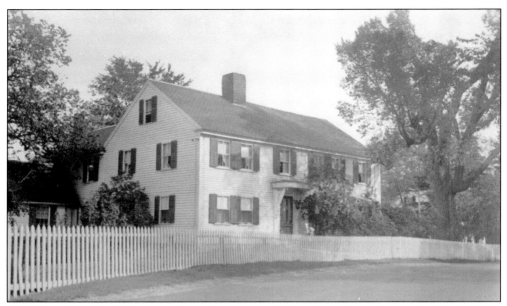

This fine old Colonial home still stands today at 41 Purchase Street. It was built in 1733 by Caleb Gardner, but it is better remembered as the home of Chester Clark, who delivered milk in Milford for many years. A select seminary for girls was taught here by Abigail Thayer from 1819 to 1822.

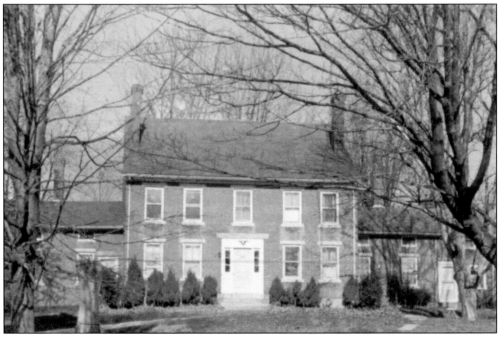

This large farm was originally owned by Jeremiah Boyington, a Mendon proprietor, in 1737. The first house was replaced with this brick home in 1808 by John Cheney. Located at 254 Purchase Street, it was one of the first brick residences built in Milford, and it is now the oldest brick house still standing.

The Elms, at 5 Elm Street, was built in 1751 by Joshua Chapin. The home was one of Milford's first inns. The inn was owned by Dr. William Jennison, who gave a brass field cannon to Milford during the Revolutionary War. According to local history, the house was in the proposed path of Sherborn Road, and the layout of the road was changed to go around it.

This house at Kapatoes Farm, at 83 Silver Hill Road, was built by Ziba Thayer in 1808. The first home on the farm was built by Col. Ichabod Thayer in 1744. Aaron Claflin bought the model farm in 1852 as his summer home. It was also run as an inn at one time. The house was razed about 1995.

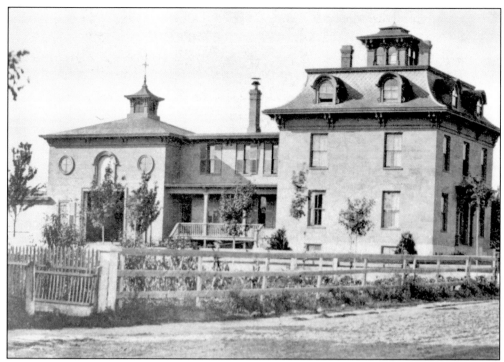

This unique mansard-roofed home was built in 1850 by Emery Walker. It stands today at 58 Congress Street. The back part of the residence, which is now an apartment, was originally built as the carriage house.

Benjamin D. Godfrey built this Victorian home in 1854 at 42 Congress Street. Anne Godfrey, a librarian, married Melville Dewey, who designed the Dewey decimal system. Later, Dr. Frank Harvey resided here and operated the Harvey Hospital next door. Today, the house is owned by Richard and Betsey Buma, who operate the Buma Funeral Home there. (Courtesy of the Bumas.)

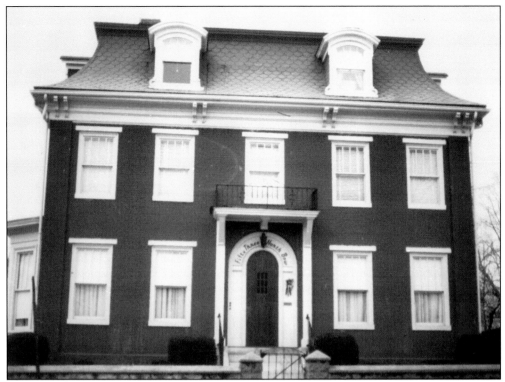

This stately brick, mansard-roofed home at 53 North Bow Street was built by Jonathon Coe Bradford in 1855. He was born in Smithfield, Rhode Island, but moved to Milford shortly before his marriage to Angeline Nelson. Bradford was a very enterprising and skillful mason.

Milford's second hospital was at 44 Congress Street, owned by Dr. Frank Harvey. It was originally built by Perley Field in 1881. Field moved to Milford in 1849 and, according to Adin Ballou, engaged in business here. Currently, the house is the Edwards Funeral Home. It is next door to the Buma Funeral Home, where Dr. Harvey once lived.

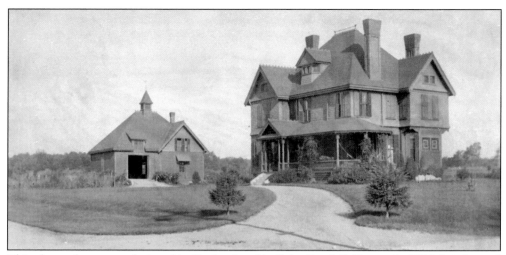

This elegant home was designed in England and built by Randall Greene in 1884. It is located at 3 West Walnut Street. Today, it is the residence of Dr. Noel C. and Evelyn BonTempo. Dr. BonTempo was trained in family medicine and is a graduate of the University of Bologna's class of 1968. (Courtesy of the BonTempo family.)

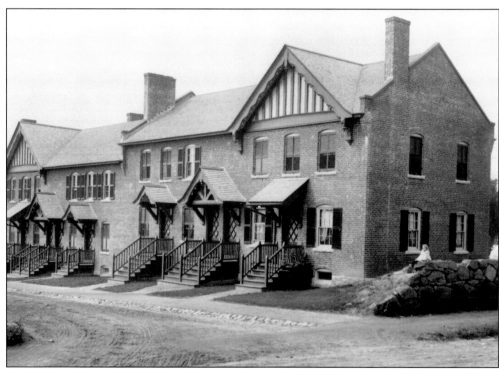

Prospect Heights is a section of Milford that was owned and built by the Draper Corporation of Hopedale, which was the world's largest manufacturer of automatic looms. The homes were built in 1903 to house families of all nationalities who worked at Draper. The neighborhood received recognition as a National Historic District in 1990.

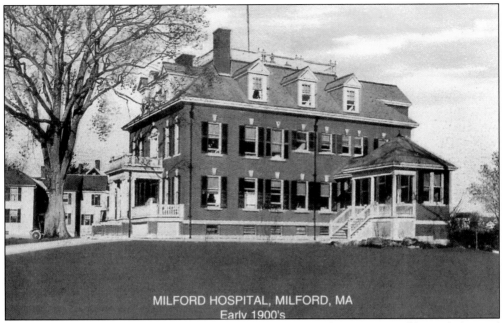

MILFORD HOSPITAL, MILFORD, MA
Early 1900's

The Milford Hospital was donated by Gov. Eben Draper on July 14, 1903, and his wife donated the nurses' home. The training school started in 1905 and closed in 1959. Continuously upgrading medical technology and expansions have kept Milford Regional Medical Center in the forefront of health care services. Today, it is associated with UMass Memorial Health Care, and the cancer center opened in 2007 with the support of physicians from Dana-Farber/Brigham and Women's Cancer Center.

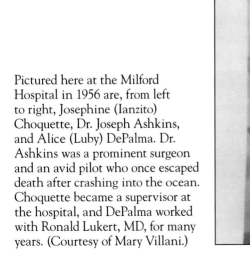

Pictured here at the Milford Hospital in 1956 are, from left to right, Josephine (Ianzito) Choquette, Dr. Joseph Ashkins, and Alice (Luby) DePalma. Dr. Ashkins was a prominent surgeon and an avid pilot who once escaped death after crashing into the ocean. Choquette became a supervisor at the hospital, and DePalma worked with Ronald Lukert, MD, for many years. (Courtesy of Mary Villani.)

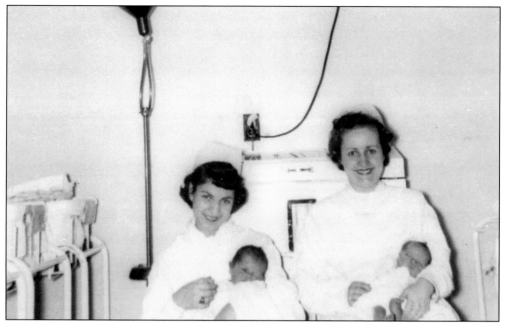

Mary Villani (left) and Joyce Baily are seen here during their training in the maternity ward at Milford Hospital in 1950. The beautiful little babies they are holding are unidentified. Milford Hospital no longer trains nurses, but it is affiliated with UMass Memorial Health Care as a training school. (Courtesy of Mary Villani.)

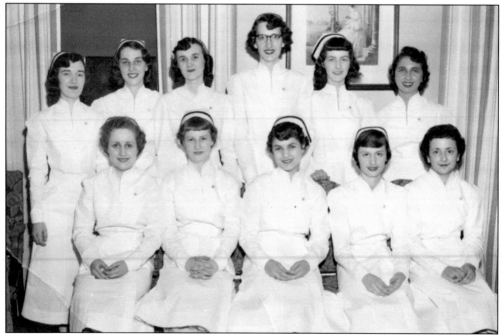

Milford Hospital Training School offered many a young lady the chance to earn an RN degree. Pictured here in 1952 are, from left to right, (first row) Joyce Baily, Dorothy Yanosich, Mary Villani, Rita Cippriani, and Elvira Sidoni; (second row) Yvonne Colmont, Doris Bonati, Pauline Gendron, Lois Ozella, Geraldine Visperi, and Grace Ferrucci. (Courtesy of Mary Villani.)

Eight

MUSIC, ENTERTAINMENT, AND PARADES

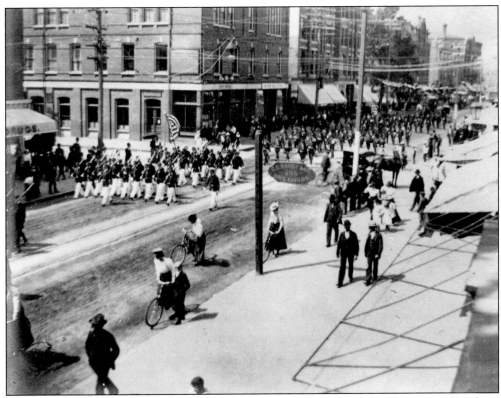

This photograph was taken on July 4, 1897. The parade is passing by G.E. Raney Dry Goods, at 206 Main Street, and the post office, at the corner of Main and Exchange Streets. The female bicyclists in the foreground may be enthusiasts attending the five-mile bicycle race between Michael Tusoni and Matthew Conlin later that day.

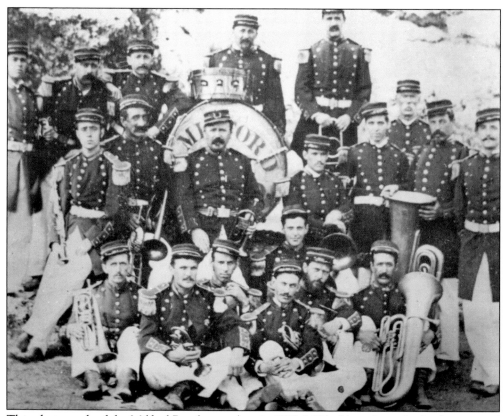

This photograph of the Milford Band was taken in 1875. Milford has always had a fine musical reputation. Charles Caruso is one of the band members, seated in the first row, second from the left. Milford has offered concerts dating back to the 1800s, in the town hall, the Opera House, Memorial Hall, and, later, in the Crystal Room.

This group was known as the Big-8 and performed after World War I, around 1919. The men played at the Charles River Driving Park Hall. Pictured are, from left to right, (first row) Michael Tumolo, Joseph Iannitelli, Alex Porzio, and Antonio Sannicandro; (second row) Joseph Tumolo, John Tumolo, Louis Iannitelli, and Michael Guido.

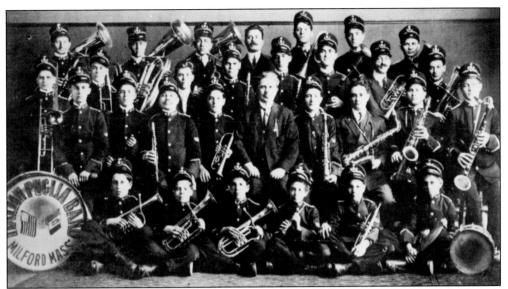

Above are members of the Puglia Band in 1918. They are, from left to right, (first row) Joseph Morcone, Boniface Longo, Mario Lancisi, Nicolas Andreola, Joseph Lombardi, and Alphonse Andreano; (second row) John Morcone, John Sciarillo, Matteo Paradiso, Dr. Frank Moschilli, Giovanni Castellucci, Michael Brita, Alessandro Iannitelli, Matthew Colianni, and Alberto Iacovelli; (third row) Salvatore DiMatteis, Anthony Sciarillo, Clemente Andreano, James Zurio, Louis Morcone, Michele Mazzone, Alfonso Santilli, and Nicholas Cardone; (fourth row) Luigi Pilla, Louis Lancisi, Anthony DiCicco, James DiCicco, Pasquale Zurio, Michele DeMaria, and Leonardo DeCapua. The 1922 photograph below shows the Milford High School orchestra. From left to right are (first row) Dr. Ralph Volk, Ben C. Lancisi, Edwin F. Lilley, and Dr. John R. Cicchetti; (second row) Samuel Bean, Frank Todino, William Mackay, and John Julian.

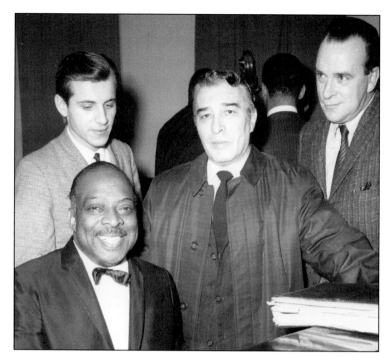

Henry "Boots" Mussulli, born in Milford in 1917, was a jazz saxophonist who spent much of his career playing in the Boston area. He played with the Stan Kenton Orchestra and worked with Gene Krupa in 1948. He enjoyed playing at the Crystal Room in town and also founded the Milford Youth Orchestra. Pictured here with Count Basie (left) are, from left to right, Michael Julian, Mussulli, and Bob Varney. (Courtesy of the Mussulli family.)

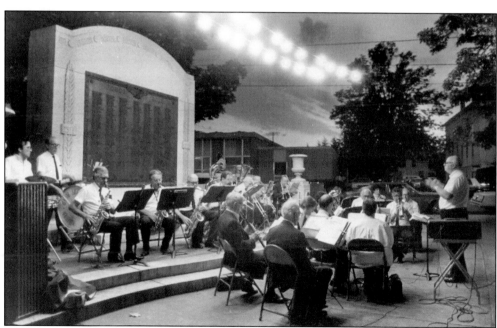

Summer concerts have been a tradition in Milford for years. This concert is conducted by Joseph Oneschuk in front of the World War I Memorial at Draper Memorial Park in the late 1950s. Nowadays, Milford residents enjoy concerts in the town park featuring Paul Surapine, Jerry Secco, and Donald Iacovelli. (Courtesy of the MTL.)

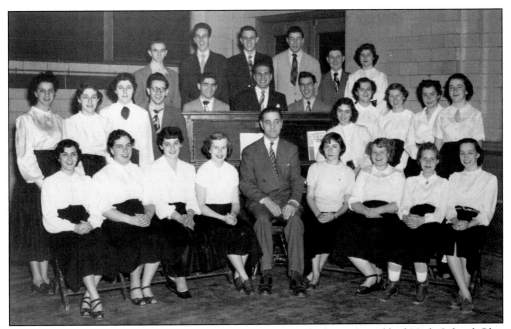

Music director Alex DiGiannantonio is pictured here with the 1951 Milford High School Glee Club. DiGiannantonio was responsible for many school and civic music programs, as well as townwide music functions that included operas, concerts, band programs, and musicals.

One of the few high school plays put on at the Opera House was *Plymouth Rose*. It was a production by Sadie O'Connell, one of the Milford's outstanding teachers. O'Connell is seated on the far left. In 1917, the school play *She Stoops to Conquer* was also produced at the Opera House.

Eleanor Norton (left) and Lillian King performed the "Polka Gallant" at the May Festival recital at the town hall on May 14, 1923. Mae Mackey was the dance teacher, and Benjamin Lancisi was musical director. King became the mother of Michael Dewart, who studied music at Boston University and played benefits for the Ladies Aid Association. (Courtesy of the MTL.)

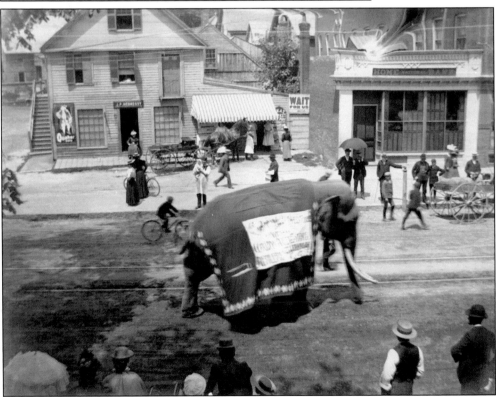

An elephant saunters down Main Street, passing J.P. Hennessy's grocery and the Home National Bank, as Milfordians stop their daily errands to stare around 1900. Note the Quaker Oats poster on the left. (Courtesy of the MTL.)

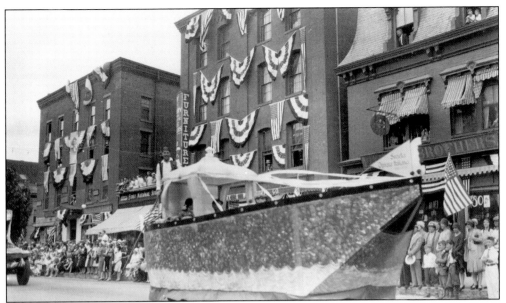

A grand Columbus Day celebration was held on October 12, 1927, by the United Italian Organizations of Milford. A purple-and-white, gondola-inspired float from the Societa Operaia began the parade. Fireworks were enjoyed by 4,000 spectators. This display of pride boosted the morale of the community, as a previous resident of Milford, Nicola Sacco, along with his friend Bartolomeo Vanzetti, had been executed on August 23 at the Charlestown State Prison in Massachusetts, despite international demonstrations supporting their innocence.

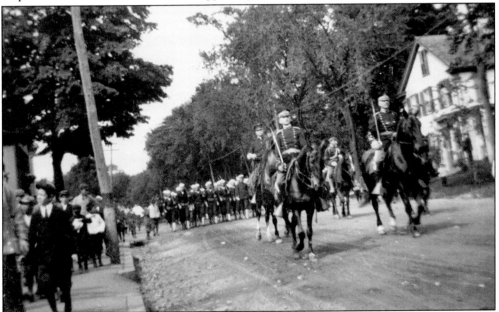

This parade was held for the dedication of the *Gen. William Franklin Draper* statue on September 25, 1912. Susan Preston Draper purchased the park for $10,000 from the First Congregational Parish and paid Daniel Chester French $50,000 for the statue. She then presented both the park and the statue to the town as a gift. The event was very well attended, with thousands of people, many of whom came into town by train.

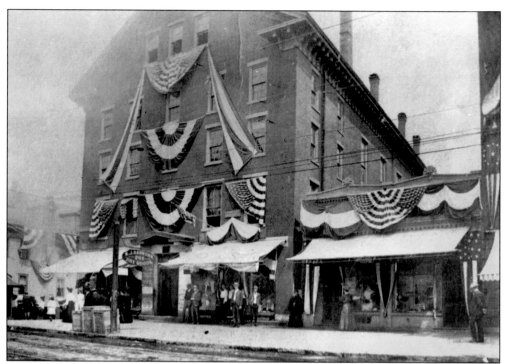

Lavishly decorated with patriotic buntings for Milford's sesquicentennial in 1930, the Washington Hall Block was built as an armory for Milford's light infantry. A grand dedication ball was held on March 15, 1854. The block was demolished on May 10, 1950, just four years shy of its centennial.

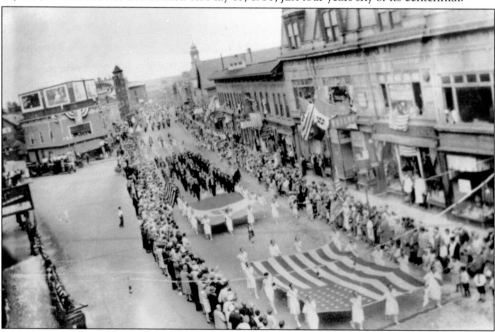

The sesquicentennial parade is shown here coming through Lincoln Square on Saturday, June 21, 1930. The parade, which started at 1:00 p.m., was part of weeklong events that included dances, parties, special church services, and a night of fireworks.

This Iwo Jima float was part of the victory parade after World War II, which was held on August 15, 1945. The Portuguese Club sponsored this float. Among Milford's contributions to the war were the 2,570 area men and women who served in the armed services. Of these, 55 men gave their lives.

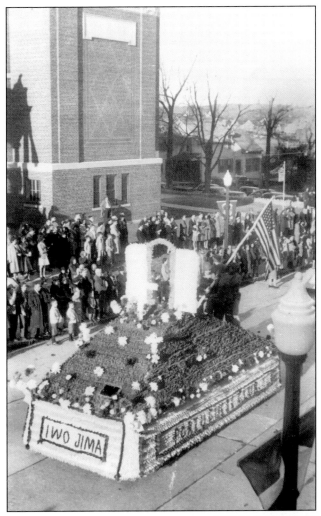

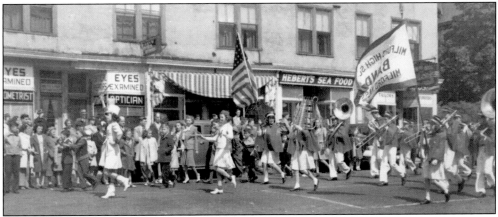

Everyone loves a parade, and this parade passes the Lincoln House around 1950. Milford still has Memorial Day and Veterans Day parades every year, proudly honoring soldiers and sailors who fought for the country. (Courtesy of the MTL.)

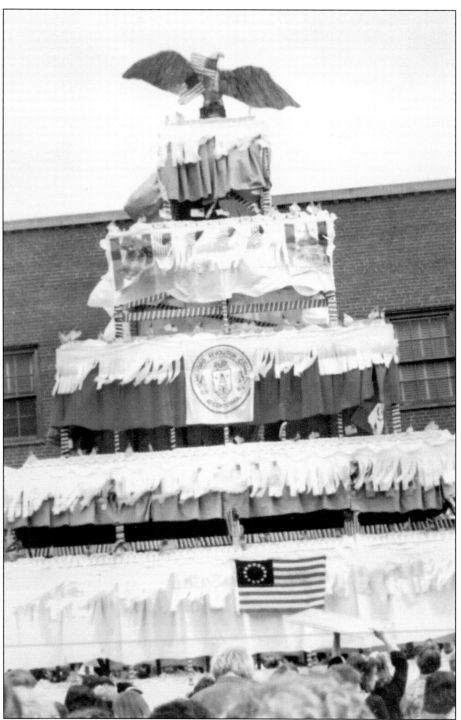

Milford celebrated the country's birthday with what was billed as the world's largest birthday cake, adorned with the wooden eagle that had stood sentinel over Milford from the town hall. About 1910, it was replaced with a metal eagle. At the end of the parade, the huge cake was enjoyed by all. The cake had six layers and was 30 feet tall without the eagle.

Nine

MISFORTUNES

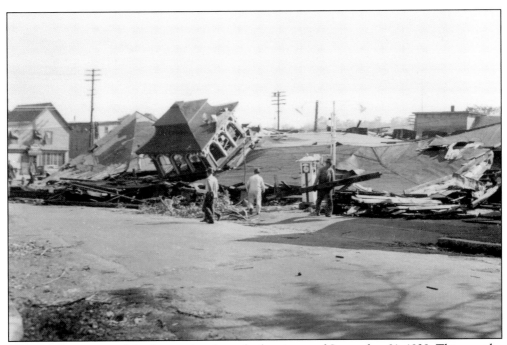

Shown here is some of the destruction from the hurricane of September 21, 1938. This was the Flanigan Leather factory, at the corner of South Bow and Central Streets. The shop was previously the Isaiah Spaulding Straw Shop. The hurricane was of unprecedented force and left the town paralyzed. Roads were washed away, and trees blocked railroad tracks. The Clark & Shaughnessy Oil Company occupied this site at a later time.

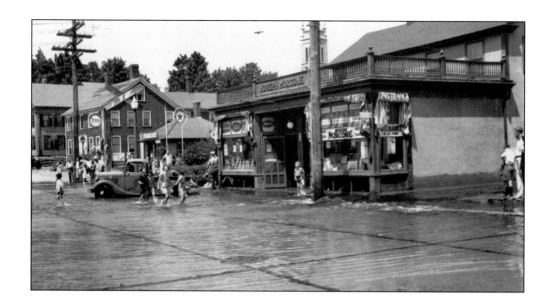

Above, everyone is having a good time playing in the water after a flash flood on July 24, 1938. The north side of Main Street is shown, in front of Joseph Morcone's market. Below is the south side of Main Street, with the N. Morelli & Sons store and Renda's ice cream store. The large crowd in front of Renda's store is getting a free ice cream from Mr. Renda. (Both, courtesy of Robin Philbin.)

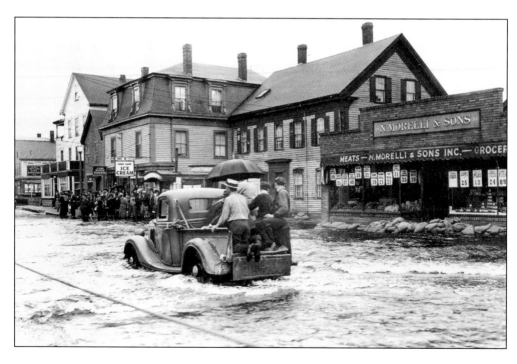

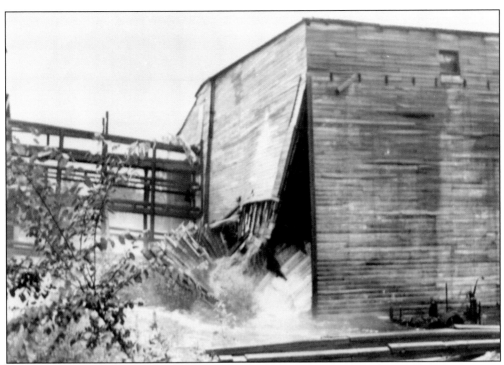

Macuen's icehouse was located on Dilla Street near Louisa Lake. During the flood of July 1938, the dam washed out and the icehouse collapsed. Ice was harvested from Louisa Lake and Parker's Pond. In 2013, one can still see parts of the dam beside Louisa Lake.

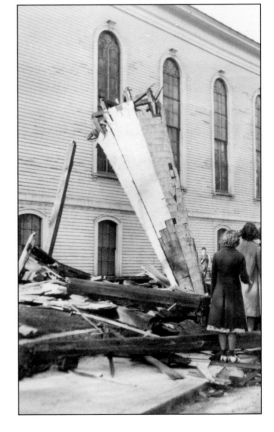

This is the steeple from the Congregational church the morning after the hurricane of September 21, 1938. The parishioners took the wood from this 120-year-old steeple and made some small mementos. (Courtesy of Paul Curran.)

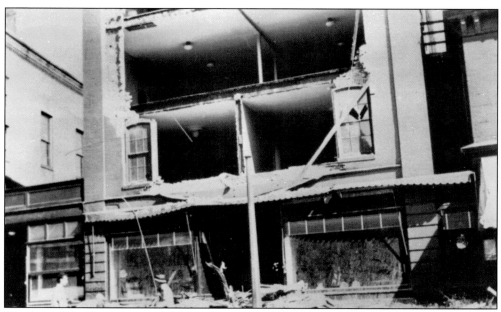

The Avery Woodbury store, at 162 Main Street in Milford, was one of several businesses destroyed in the hurricane of 1938. The economic loss was great, and repairs were made slowly to the town, since people did not have many tools that are commonplace today. Citizens were also caught off guard, as they did not receive any warning of the approaching storm.

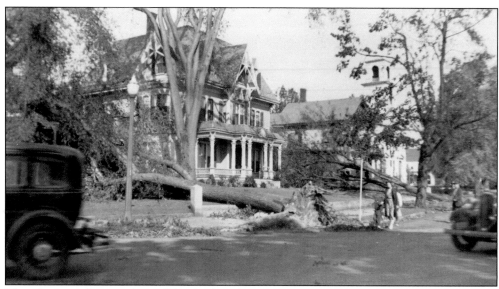

This photograph was taken of Dr. Curley's home on Congress Street the morning after the Category 3 hurricane struck Milford on September 21, 1938. This house was located just two houses before the Congregational church. The hurricane included record gusts, with winds over 120 miles per hour.

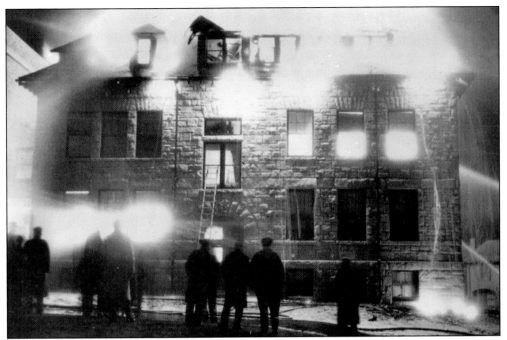

Shown here is the fire in the winter of 1937 that destroyed the third floor of what is now Stacy Middle School, facing School Street. The fire destroyed many gifts given to the school from former classes. It originally had a mansard roof.

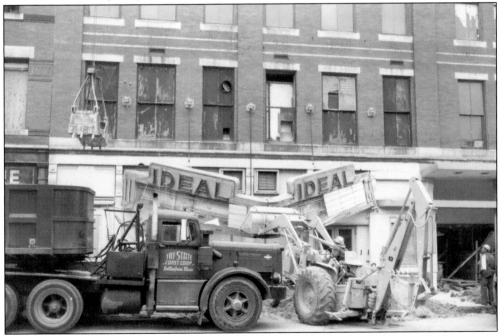

The Ideal Theater was damaged in the 1962 fire that engulfed Werber & Rose and other nearby businesses. Shown here is the demolition of the popular movie theater. The State Theater, located on Park Street, was also popular. Note the lion's heads that adorned the building. (Courtesy of the MTL.)

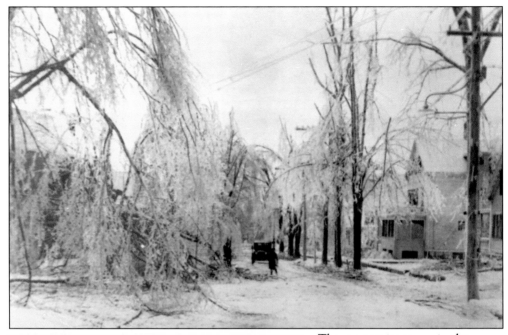

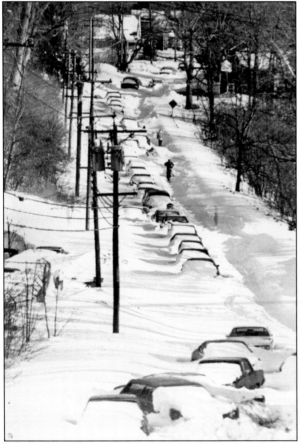

The greatest ice storm in the history of the state, on November 27, 1921, raged for three days. Wires were covered with nearly two inches of ice. Poles, wires, and trees were down, and there were no lights for one to three weeks. Trolleys were out, too. This photograph was taken on Franklin Street.

This photograph was taken from the Route 495 overpass looking at Route 16 toward Holliston the morning after the great blizzard on February 6, 1978, which dropped 27.1 inches of snow on Milford. The town came to a standstill for over a week before the National Guard dug it out.

Ten

NOTABLE MILFORDIANS

Dr. Joseph E. Murray was the 1936 salutatorian of Milford High School. He graduated from Holy Cross College and Harvard Medical School and began his internship at Peter Bent Brigham Hospital. He served in the Army Medical Corps and went on to join the surgical staff at Peter Bent Brigham Hospital. He was the lead surgeon on the world's first successful human kidney transplant, on December 23, 1954, for which he shared the Nobel Prize in Physiology or Medicine in 1990. Dr. Murray passed away in Wellesley on November 26, 2012. (Courtesy of Brian Murray, Esq.)

Adj. Gen. Alexander Scammell was born in Milford in 1744. He fought alongside George Washington and crossed the Delaware with him, taking part in the Battles of Trenton and Princeton. In 1780, Washington appointed him adjutant general and colonel of the 1st Regiment of New Hampshire. He was shot in the side in the Battle of Yorktown and died of his wounds on October 6, 1781.

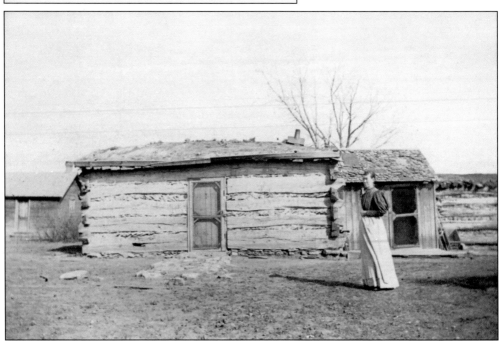

Cherokee, Iowa, was founded by pioneers from Milford. The group, known as the Milford Emigration Company, arrived there by wagon train on May 11, 1856. It was organized by Dr. Dwight Russell and Dr. Slocum and numbered 54 members in all. Pictured here is a pioneer of the west.

Rev. Adin Ballou was born in 1803 and died in 1890. He was a Unitarian minister who was a proponent of pacifism, socialism, and abolitionism. He wrote *History of Milford*, which he started in 1876 and took six years to complete. The extensive publication has two parts: the history and the genealogy of the families.

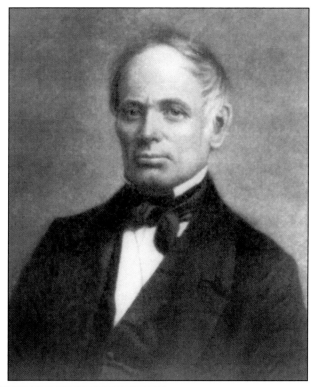

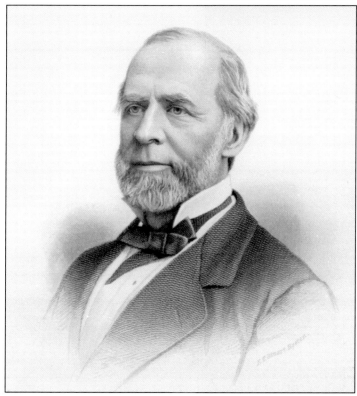

Gov. William Claflin was born in 1818 and died in 1905. He was an industrialist and philanthropist who served as governor of the commonwealth and as a member of Congress from 1877 to 1881. He was born in Milford, educated at Brown University, and elected governor in 1868, where he was known for his support of women's suffrage. He donated funds to start Claflin University, a historically black Methodist university in South Carolina.

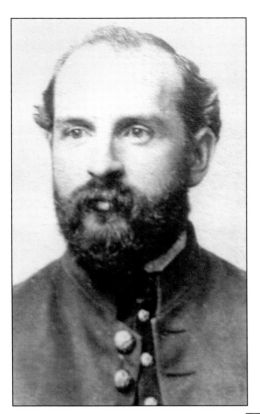

Capt. Otis W. Holmes was a Civil War hero. He enlisted on September 9, 1861, as a private in Company B, 25th Massachusetts Regiment. He was mortally wounded in battle and died in June 1864 in Washington, DC.

The 1865 *Milford Directory* lists Augustus Tuttle's occupation as a boot finisher. At the outbreak of the Civil War, Tuttle enlisted to serve his country. He served as quartermaster with the 36th Massachusetts Volunteers, Company F. Honorably discharged in 1865, he returned to Milford and started a business making home furnishings. The Tuttle building still stands at the corner of Main and Jefferson Streets.

Franklin W. Mann was an enterprising man who carried on a business at 64 Central Street. He invented the Mann Bone Cutter for poultry food and patented it on August 20, 1889. His work premises included three floors, where he maintained a well-equipped shop for all kinds of machine repairing. He also wrote *The Bullet's Flight from Powder to Target*.

Dr. William Clark, born in 1843, practiced medicine in Milford for over 50 years. He was the medical examiner for 40 years. Medical schools opened around 1850 and charged medical students $5 a year for two years of education. To gain admission, one was required to know some Greek and enough Latin to read and write prescriptions.

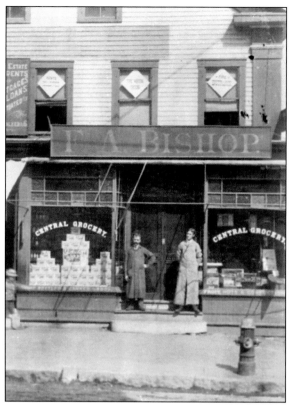

F.A. Bishop Grocers was located at 200 Main Street. Frederick Bishop was born in Boston in 1860 but moved to Milford as a stonecutter. In 1893, he bought out W.H. Baker's grocery store. Bishop and his wife, Etta, lived at 24 Emmons Street. Sadly, he died of pneumonia at age 38. He is seen here on the left with his clerk George Heath in 1896. (Courtesy of the MTL.)

A founding family of Milford, the Cheneys gathered for this reunion on August 15, 1899. Four generations, including the youngsters in the foreground with their favorite dolls, enjoyed a summer day on the old homestead. Edwin Cheney, born in 1835, may be the old gentleman sporting a beard and a straw hat on the left.

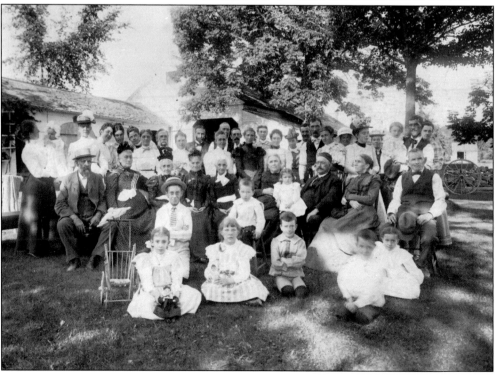

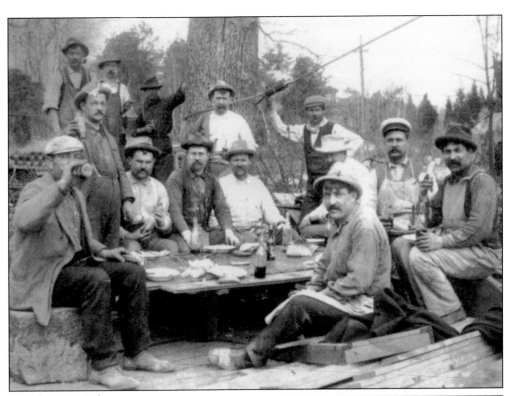

Seen here are Italian stonecutters at the Milford Pink Granite Company. Second from the right with the white cap is Charles Caruso, Milford's first Italian police officer. He also designed the Doughboy Monument and was an organizer of the Sacred Heart Parish. This photograph was taken around 1905. (Courtesy of Robin Philbin.)

The two children shown here ready for a party are Kenneth Cook (1892–1907), the son of Judge Clifford and Addie Cook, and his cousin Dorcas Whipple (1895–1991), the daughter of Frank and Edith Whipple. Cook died young from appendicitis, and Whipple was an art teacher in Milford for many years.

Archer Rubber Company, at 213 Central Street, was founded by Stephen Durkee Archer in 1907. It is still a leading supplier of high-quality rubber-coated fabrics. The factory ran around the clock, making foul-weather outerwear for soldiers during World War II. Seen here, from left to right, are Stephen, Alecia, Lillian, Stephen Calvert, and Mary (Poole) Archer.

Robert Allen Cook (1872–1949) was one of Milford's noted architects. He was only 28 years old when he was chosen to design the addition on the town hall. He is also known for designing the Universalist church, the first Milford Hospital, and several other beautiful buildings in Milford. He was also the architect for several of the homes built by Draper Corporation.

Dr. Joseph E. Murray performed the first successful human kidney transplant in 1954, for which he shared the Nobel Prize in Physiology or Medicine in 1990. He was born in Milford in 1919 and never forgot his hometown. He was a humble and gentle man. Murray (second from right) is pictured here with his family—from left to right, Norma Murray (Ervin), William Murray Jr., Mary (DePasquale) Murray, and William A. Murray. (Courtesy of Brian Murray, Esq.)

Augusto and Rose (Bergamini) Bega are seen here at their family farm on Birch Street around 1930. This area of town remained farmland until around 1970. Today, industrial parks are located in the area, which is home to the Waters Corporation, the Birchwood Business Park, EMC, and the Birch Street Fire Station. (Courtesy of the MTL.)

Thomas F. Davoren (left) and David I. Davoren ride a pony on the family farm on upper Purchase Street around 1916. Thomas became a well-known pharmacist and operated Davoren's Pharmacy on Water Street, while David became superintendent of Milford Public Schools. (Courtesy of Paul Curran.)

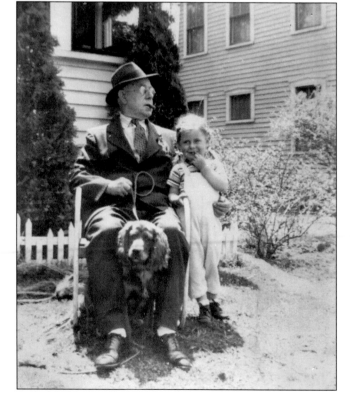

John Higginston was the postmaster of the Milford Post Office in the 1930s and 1940s. He is seen here at his home at 274 Main Street with his granddaughter Donna Collins, born in 1944, and his dog Cappy. The post office has occupied many sites; at that time, it was in the police station building.

The "Water Street Gang," pictured here in 1953, includes, from left to right, Bernard Tessicini, Brian Fitzgerald, Frank Rummo, Anthony Ferrante, and Joseph Pontonio. For 60 years, these men have had an annual reunion. (Courtesy of Bernard Tessicini.)

Seen here are eight sets of twins standing on the steps of St. Mary's Academy. From left to right are (first row) Margaret and Mary O'Brien (b. 1954), David and Paul Flaherty (b. 1956), James and Mary Ellen Curley (b. 1958), and Margaret and Mary Kearnan (b. 1956); (second row) Susan and Evelyn Davoren (b. 1955) and John and Cyril Kellett (b. 1953); (third row) John and Mary Sullivan (b. 1949) and Jane and Jean Cormier (b. 1949). (Courtesy of the Newton family.)

Joseph Rosenfeld, the owner of Rosenfeld Concrete, was an entrepreneur, banker, and friend of the community. He was vice chairman of the Home National Bank and served the Milford Hospital in many capacities. Among other things, he was a trustee of the Milford Hebrew Association. He is seen here on the left with Franklin D. Roosevelt Jr. at the United Jewish Appeal in April 1951. (Courtesy of Allan Bain, through Paul Butcher.)

A Halloween party in 1957, complete with decorations of skeletons, black cats, and paper hats from Dennison's, was held at the Dewart home, at 35 Pleasant Street. Michael Dewart (third from the left) became an accomplished pianist and made his debut at Carnegie Hall in 1965. In the background, his mother, Lillian (right), and a guest look on. (Courtesy of the MTL.)

Parliamentary law expert John F. Curran (left) presided over 120 consecutive Milford town meetings using his ancestral 1820 Irish shillelagh. He was the founder of Curran Express, the director of the American Trucking Association, and the president of Veterans of the Merchant Marines. Posing with Curran is John F.X. Davoren, the Speaker of the Massachusetts House of Representatives from 1964 to 1967 and Massachusetts's 24th secretary of the commonwealth. (Courtesy of Paul Curran.)

Father Francis W. Sweeney, a Jesuit from Milford, brought Robert Frost and other notable authors to Boston College. Sweeney himself was a gifted writer of poetry and literature. Pictured here in 1962 are, from left to right, (first row) Father Sweeney, Elizabeth O'Brien, Robert Frost, and Gerard Sweeney; (second row) Leroy Buechele, Margaret Sweeney, Mary (Sweeney) Buechele, Patricia (Baker) Fala, James Baker Jr., Richard Baker, James Baker, Robert Baker, and Anne (Sweeney) Baker.

This photograph was taken at a My One Wish Foundation fundraiser in 1975. From left to right are Larry Glick, the radio host on WBZ; Edward Thompson of WMRC radio; Anthony Brenna, the foundation's chairman and founder; and Rep. Marie Parente. My One Wish is a nonprofit organization that grants wishes to seriously ill children.

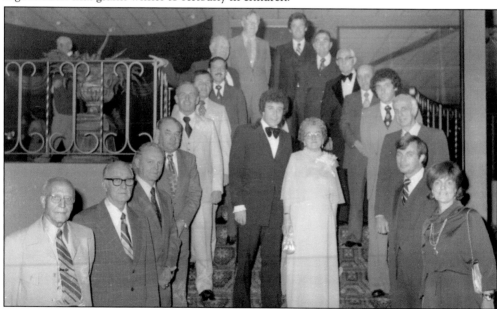

Catherine Coyne's party in 1978 was held to honor her 50 years of service to the town. She was known as Milford's "First Lady of Politics." She is seen here with Emilio Diotolevi and, from left to right, Vincent Votolato, John Pyne, Thomas Cullen, William McAvoy, John Maher, Louis Guerriere, Reno Deluzio, John Casey, Robert Holbrook, Louis Bertonazzi, Marco Balzarini, Adam Diorio, Michael Visconti, John Fernandes, Domenic D'Alessandro, Michael Noferi, and Marie Parente. (Courtesy of the MTL.)

This photograph was taken around 1950 of children leaving St. Mary's Church in a procession after receiving their First Holy Communion. From left to right are Sister St. Edward, Patricia Clark, Anne Hanlon, and Rita Lampson. Sister St. Edward was a nun belonging to the order of the Sisters of St. Joseph.

Leo F. Curran is shown here while serving in World War II. After the war, he became the road manager of the Stan Kenton Orchestra as well as the co-owner of Curran Lumber Company. He was a founding member of the former Milford Area Youth Orchestra, along with the late Henry "Boots" Mussulli. (Courtesy of Paul Curran.)

DISCOVER THOUSANDS OF LOCAL HISTORY BOOKS FEATURING MILLIONS OF VINTAGE IMAGES

Arcadia Publishing, the leading local history publisher in the United States, is committed to making history accessible and meaningful through publishing books that celebrate and preserve the heritage of America's people and places.

Find more books like this at
www.arcadiapublishing.com

Search for your hometown history, your old stomping grounds, and even your favorite sports team.